Paintings from the Royal Academy

The exhibition was made possible through a grant from BATUS Inc.

A Britain Salutes New York Festival presentation

International Exhibitions Foundation

Paintings from the Royal Academy

Two Centuries of British Art

Hans Fletcher *Assistant Secretary, Royal Academy*

Paintings from the Royal Academy
Two Centuries of British Art

The exhibition was made possible through
a grant from BATUS Inc.
A Britain Salutes New York Festival presentation

Organized and Circulated by the
International Exhibitions Foundation
Washington, D.C.

Participating Museums

The Society of the Four Arts
Palm Beach, Florida

New Orleans Museum of Art
New Orleans, Louisiana

Cincinnati Art Museum
Cincinnati, Ohio

San Antonio Museum of Art
San Antonio, Texas

National Academy of Design
New York, New York

Virginia Museum
Richmond, Virginia

Seattle Art Museum
Seattle, Washington

Delaware Art Museum
Wilmington, Delaware

The exhibition has received an indemnity from
the Federal Council on the Arts and the
Humanities.

Additional funding for the project has been
provided by The British Council. The catalogue
is supported in part by a grant from The
Andrew W. Mellon Foundation.

© 1982 International Exhibitions Foundation
Washington, D.C.
Library of Congress Catalogue Card
No. 82-082937
ISBN: 088397-043-0

Printed for the International Exhibitions
Foundation by
Garamond/Pridemark Press, Baltimore,
Maryland
Designed by Derek Birdsall

Cover Illustration: No. 21, Henry Singleton, *The
Royal Academicians in General Assembly* 1795

Britain Salutes
New York 1983

Acknowledgments

Since its founding in 1768, the Royal Academy of Arts has played a considerable role in the development of British art. A repository for some of the greatest works in the history of British painting, as well as magnificent examples from other countries, the Royal Academy continues to serve as a meeting place for artists and the public to discuss and evaluate artistic ideas. The Academy's collection, located in the splendid Burlington House, comprises over fifteen hundred works, including sculpture. From such a vast selection, the exhibition organized by the International Exhibitions Foundation together with the Royal Academy takes a very special look at British art, artists and patrons over the last two centuries.

There are several portraits, as well as the stupendous group painting, *The Royal Academicians in General Assembly*; also included are highly academic works of artists such as Poynter and Alma-Tadema, together with the delightful oil sketches of Constable and the engrossing drawings of Benjamin West, an expatriot American, who spent most of his artistic life in England.

This is the first time that the Royal Academy has lent so many works for a single exhibition, and we are most fortunate to have the opportunity to show these beautiful works to the American public. We owe special thanks to Sir Hugh Casson, President of the Academy, and Sidney Hutchison, Honorary Archivist, for their contributions both to the exhibition and the catalogue, and to Sir Ellis Waterhouse for his thoughtful catalogue foreword. Throughout this project, Hans Fletcher, Assistant Secretary of the Academy, has lent his deft hand in solving many of the myriad problems in bringing the exhibition across the Atlantic, and he has also written the catalogue entries.

His Excellency Sir Oliver Wright, the British Ambassador, has graciously agreed to be patron of the exhibition during its tour, and we wish to thank him, as well as Hugh Crooke, Cultural Attaché, and members of their staffs for invaluable assistance in making the exhibition a success.

Of uppermost concern in any project of this scope is the financial foundation on which it rests. We are most grateful that BATUS Inc. has provided us with a generous grant towards the exhibition and tour. The exhibition is a Britain Salutes New York Festival presentation to be celebrated in the Spring of 1983. Also greatly deserving of our thanks is the Federal Council on the Arts and the Humanities which has provided an all-important indemnity for the exhibition. Additional assistance to the overall project has been provided by The British Council. The catalogue, handsomely designed by Derek Birdsall and printed by Garamond-Pridemark Press with the capable assistance of Alan Abrams, is partially underwritten by The Andrew W. Mellon Foundation.

Finally, I reserve my special thanks for the staff of the International Exhibitions Foundation who characteristically have worked very hard to make this exhibition a reality, notably Janet Walker for editing the catalogue text and seeing the catalogue through production, and Taffy Swandby, Christina Flocken and Bridgett Baumgartner for attending to the many details involved in organizing and circulating the exhibition.

Annemarie H. Pope O.B.E.
President
International Exhibitions Foundation

Royal Academy of Arts by Sir Hugh Casson K.C.V.O., P.R.A.

Preface

by Sir Hugh Casson K.C.V.O., P.R.A.
President of the Royal Academy of Arts

The Royal Academy is proud of its collection of treasures, proud too of its record in lending them whenever possible to appropriate galleries and institutions both in the United Kingdom and abroad.

This is the first time, however, that a group of works of such quality and distinction from the Royal Academy has ever left these shores. That we have gladly agreed to this – and for so long a time – is a tribute to the reputation of those galleries in the United States who will be the hosts, and an indication of our wish that the works should be widely seen and enjoyed.

We are greatly indebted to the International Exhibitions Foundation and in particular to its President, Mrs. John A. Pope, under whose auspices this traveling exhibition has been arranged. We are confident that the works will arouse great interest wherever they are shown and will lead, we hope, also to a wider interest in and knowledge of the Royal Academy of Arts itself.

Foreword

by Professor Sir Ellis Waterhouse C.B.E.

During its first hundred years – and all but three of the pictures in the exhibition fall into that period – the Royal Academy was very much at the center of the world of English painters in oil. (Watercolor painting was unimportant when the Academy was founded in 1768, and when it became very fashionable in the early years of the nineteenth century, the watercolorists never felt that the Academy treated them quite as seriously as they would have liked and founded societies of their own.) Except for Hogarth, who belonged to an earlier generation, this hundred years was also the great period, what we now call the "classic age" of British painting, in which Reynolds and Gainsborough were the dominant figures in the eighteenth, and Turner and Constable now appear as the dominant figures in the first half of the nineteenth century. This does not mean that every oil painter of consequence exhibited at the Royal Academy – Romney, for instance, never did. He was probably excluded at first by the jealousy of the first President, Sir Joshua Reynolds, but he soon found that a really fashionable portrait painter didn't need to exhibit at the Academy. But Romney's case was rather an exception.

The notion of requiring a Diploma Work from every painter who was elected to the Royal Academy was taken from the practice of the French Academy, but it was not insisted upon with the same rigorousness that prevailed in Paris. A number of the Foundation Academicians never submitted one, while many later Academicians presented as their Diploma Works pictures which were not altogether characteristic of their styles. The French had taken care to avoid this, since, once an artist had been *agréé*, he was allotted a subject and was not formally received into the Academy until this work had been accepted and approved. Thus the London Academy's collection of Diploma Works, although it survives intact, never provided the same sort of conspectus of the history of British painting. Fuseli, Beechey, Raeburn and Etty presented very characteristic Diploma Works, but, of the examples in the present exhibition, neither the Lawrence nor the Turner gives a full impression of the artist's powers.

In another way the English differed from the French Academy. Although both were founded under royal patronage, the word "patronage" meant much more in France than in England. It is true that a number of works painted for George III (by Gainsborough, Zoffany and Benjamin West, for instance) were exhibited at the Academy, but George III was more of a nuisance than a help in the Academy's internal politics.

At the time of its foundation in 1768, the landed classes were the only serious patrons of art, and they limited their acquisition of pictures by British artists to portraits of their families, their horses, their dogs and their houses. This situation prevailed up to the time of the French Revolution. The great achievement of the Academy was to change the pattern of art patronage in Britain.

The problem was to persuade the middle classes to buy pictures. Hogarth had discovered in the 1740s that, although buyers could not be found for his subject pictures, engravings after them, sold at modest prices, found a very large market. Also, during the later eighteenth century, England was served by extremely competent engravers, at first in mezzotint, and later also in stipple. A great many of the subject pictures exhibited at the Royal Academy, including many by painters whose names are quite unfamiliar today, were engraved at the time they were painted, and, perhaps in many cases, painted specifically to be engraved. This applies not only to historical pictures by artists like West, but to theatrical subjects and rustic and urban genre, as well as to illustrations from poetry or romance. The walls of the living rooms and bedrooms of unpretentious homes seem to have been decorated by the end of the century with these prints after pictures, and some of the more adventurous of the middle classes, who were becoming richer, actually bought the originals. Only a handful of members of the aristocracy made any effort, usually rather a self-conscious one, to collect together a modest group of paintings by British painters. However, with the redistribution of wealth as a result of the Industrial Revolution, the pattern of patronage after the Napoleonic wars was very different.

Interested criticism of Academy exhibitions was pretty scarce in the eighteenth century, but, in the nineteenth, new periodicals (at first, often

rather short-lived) began to take an interest in the arts. The *Atheneum*, started in 1828, and finally the *Art Union*, begun in 1844 and continued after 1849 as the *Art Journal*, which gave a very extensive coverage indeed to the Royal Academy exhibitions, marked the moment when a complete change in the pattern of patronage had been achieved. Although the upper classes still flocked to the private view to see one another's portraits, it was the middle-class public whose enthusiasm decided what was "the picture of the year." As art galleries grew up in the provinces, it was that type of picture which they hoped to acquire. The kind of subject which appealed to rich businessmen, and the provincial galleries they supported, often seems rather surprising to us today and is well represented by the pictures of Sir Edward Poynter and Sir Lawrence Alma-Tadema. Their knighthoods are evidence that the style of their paintings chimed with the taste of the more cultivated members of the public. In the 1870s and 1880s the Academy was still very much in the center of the national feeling for the arts.

For fifty years or so the Royal Academy exhibitions were the only place where the ordinary Englishman, or the visiting foreigner, could see what contemporary painting was like – without the rather laborious business of visiting the artists' studios. The young painter also could study at ease the work of the accepted masters and model his own upon it – though perhaps "at ease" is not an accurate statement. For the pictures were hung, in the early days, in as many as five rows, from floor to ceiling and almost crammed together like the pieces of a jigsaw puzzle. Many of the pictures cannot in fact have been possible to see seriously at all, and the crowds round the "picture of the year" in the earlier nineteenth century were sometimes phenomenal. A rail had to be placed to prevent the public from kicking the pictures below it to pieces!

Any selection of less than fifty pictures can only give a very brief conspectus of the way British painting developed and changed over the century or so since the Academy began. The present group has been chosen from the center of the tradition.

Introduction

by Sidney C. Hutchison c.v.o.
Honorary Archivist, Royal Academy of Arts

The Royal Academy of Arts in London, founded in 1768, is the oldest established institution in Great Britain solely devoted to the fine arts. Subject only to the authority of the Sovereign, it also appears to be unique in the world as a self-supporting, self-governing body of artists which, on its own premises, conducts art schools, holds open exhibitions of the work of living artists and organizes loan exhibitions of the arts of present and past periods, irrespective of their origin. These activities, together with the control of numerous trust funds for various but specific purposes connected with the fine arts, not only provide an important link between artists and the general public but, being relatively unhampered by problems of different languages, upbringings or politics, have considerable potential for the encouragement of better understanding and goodwill between peoples of all nations.

The institution's "Instrument of Foundation," signed by King George III as the Academy's "patron, protector and supporter," defined the membership and laid down the basic rules. It decreed that there should be forty Academicians, and it named the first thirty-four, including Joshua Reynolds, Benjamin West, Richard Wilson, Thomas Gainsborough, Paul Sandby, the sculptor Joseph Wilton and the architect William Chambers. Reynolds became President and gave his first Discourse at the official opening of the Schools on 2 January 1769. A class of Associates was instituted almost immediately and the first

Exhibition, comprising 136 works, was held from 25 April to 27 May that year. Lawrence, Turner and Constable were among the early students; the Keeper (that is, head of the Schools) was George Michael Moser, and the Professors included William Hunter (Anatomy), Oliver Goldsmith (Ancient History) and Reynolds's particular friend, Samuel Johnson (Ancient Literature).

The exhibitions and meetings for the first eleven years were held in modest premises in Pall Mall, although the Schools and Library were given some apartments in old Somerset House, then a Royal Palace, in 1771. This building was demolished a few years later when Chambers was commissioned to design the present Somerset House, with rooms for the Royal Academy on the Strand frontage. On the death of Sir Joshua Reynolds in 1792, Benjamin West succeeded him as President until 1820 and he, in turn, was followed by Sir Thomas Lawrence, Sir Martin Archer Shee, Sir Charles Lock Eastlake and Sir Francis Grant. During Shee's time, in 1837, the Academy transferred to another new building, this time in Trafalgar Square, which it shared with the then recently founded National Gallery. But this soon proved too small to house both institutions and, in 1868, one hundred years from the Academy's inauguration, there was the final move to its present home, Burlington House in Piccadilly. A third storey was added to the house itself (built in the 1660s but afterwards considerably altered in Palladian style), and the

exhibition galleries and schools were built on the gardens to the North.

At last the institution not only had adequate accommodation for its original activities, much as they had grown in scope, but was also able, from 1870, to embark on its series of loan exhibitions of the arts of other times and of other cultures. They were for many years on a relatively small scale and held for no more than a few weeks each winter but, under Lord Leighton, President from 1878 to 1896 and a much-traveled man with a wide knowledge of foreign works of art, their range was considerably increased. Their content, of Old Masters and works by previous Members of the Royal Academy, was perforce confined for the first fifty years or so to borrowings from collections in the British Isles (long before the country's stately homes were open to the public, of course). By the 1920s worldwide communications and transport had developed to such an extent that it became possible to obtain loans of works from abroad, and there began a great series of international exhibitions, the like of which may never be seen again. They were marvelous but almost too abundant and rich in content. These days the costs involved and the problems of conservation and security would be prohibitive.

Such exhibitions are now, quite rightly and understandably, much more selective and are usually based on less diverse themes – the work of a particular artist perhaps or but one aspect or period of a nation's culture. In 1952, the Academy

increased its activities in this field to some four or five exhibitions a year, and now, by using every available space at all times, it holds ten or twelve. Unfortunately, this has involved keeping many of its own works of art in store.

The Academy's possessions were all acquired by one of three means – by a clause in the Instrument of Foundation, by purchase or by gift. The first of these is the only one requiring explanation and, in fact, has been the institution's chief source in building up a collection of pictures and sculpture, a real need in the early days when there were no public art galleries. Subsequent to the Foundation Members, every new Academician has been obliged to deposit in the Royal Academy – "to remain there, a Picture, Bas-relief, or other specimen of his abilities" – before receiving his Diploma signed by the Sovereign. These are known as Diploma Works. It is an interesting collection, particularly because the choice in each case was the artist's. Fuseli submitted an allegorical subject, Constable a Dedham landscape, Wilkie a genre picture and Etty a large nude. There is the well-known *Boy and Rabbit* by Raeburn and typical works by Chantrey, Watts, Sickert and Munnings, among many others.

In the main the purchases have been items connected with the Academy's history, such as the fifty-three profile drawings by George Dance of his fellow Members, but the gifts have been very varied. Reynolds presented a fine *Self-Portrait* and *Sir William Chambers*, and Gainsborough's daughter gave his *Self-Portrait* and a large landscape. Constable's daughter gave fifteen of her father's sketches, and Charles Landseer bequeathed a number of drawings by George Stubbs for *The Anatomy of the Horse*. There have also been important gifts from benefactors who have had no such direct connection with the institution's activities, for example, Constable's *The Leaping Horse*, a collection of Turner's *Liber Studiorum* prints and, in 1830, the Carrara marble relief of *The Madonna and Child with the Infant St. John* by Michelangelo. The marble was carved in 1504–05 and first belonged to a Florentine patron named Taddeo Taddei in whose family house it remained until early in the nineteenth century. Sir George Beaumont bought it in 1822. When he died in 1827, his will left it to his widow with the request that, unless she directed otherwise, it should eventually become the property of the Royal Academy. This tondo is one of only four major sculptures by Michelangelo outside Italy and it is indeed a precious possession.

The annual Summer Exhibition, of the work of living artists, has been held every year since 1769. Members are allowed to send in not more than six works and any other artist may submit three. There are no regulations as to age, training, nationality or domicile, but works have to be delivered on specified dates (usually in March). About 13,000 items are received each year (from around 4,500 artists) and an exhibition of some 1,200 to 1,400 is formed.

The Members of the Royal Academy (comprising, under the current laws, fifty Academicians and twenty-five Associates, all being painters, graphic artists, sculptors or architects, professionally active in the United Kingdom) serve by rotation on Council to superintend the institution's affairs; on reaching seventy-five years of age they become supernumerary and are no longer eligible for duties but, as Seniors, they continue with their full voting powers and other rights. In addition there are strictly limited classes of Honorary Membership consisting of men and women of distinguished reputation in their respective vocations. The conduct of the Academy, through its Officers, Council, Committees and Staff, is both professional and democratic, the only real difficulty being the dearth of adequate finance.

Way back in the eighteenth century, for the first twelve years from the foundation, the institution's deficits were paid by the King through the Privy Purse and, from 1780 to roughly 1914, profits were made from its exhibition activities; a considerable proportion of these was used for the new buildings at Burlington House in the nineteenth century and the remainder was invested. From 1914 to 1945 there were more often than not small deficits but these were covered by investment income. Since the Second World War, however, it has become more and more difficult for the Academy to finance its activities. For a time, the resultant deficits were met by eroding capital and, in 1962, by the sale of an important possession.

Subsequently, even with the intensive use of the premises, developing its business potential, levying fees and commissions, obtaining partial sponsorship for most of the loan exhibitions and, above all, instituting an organization of Friends of the Royal Academy (now some 30,000 in number), the bank overdraft and the diminution of capital have reached unacceptable levels.

The costs of maintaining the premises and staffing them (to the minimum degree consistent with being able to undertake relevant activities) are heavy items far in excess of the Academy's regular income, and while the institution's central position and reputation enable its financial results to compare favorably with similar endeavors elsewhere, art exhibitions can seldom be made to pay for themselves when overheads are taken into account.

It is, of course, unthinkable to the Academy that its activities might have to cease or be so curtailed as to destroy the usefulness of its service to the nation and its interest to other countries. All efforts are being made to avoid this, including the recent formation of the Royal Academy Trust, and these hopefully will be successful.

Catalogue notes

Measurements are given in inches, height preceding width.

The date of a Diploma Work under *Collection* indicates the year in which it was deposited and is sometimes at variance with its execution.

The abbreviations R.A. and R.A. Winter under *Exhibitions* refer to Summer Exhibitions and the list of Winter Exhibitions contained in S.C. Hutchison's *History of the Royal Academy* (Chapman & Hall), 1968, pp. 241–3, together with a selected bibliography pp. 245–7.

Other abbreviations used are: O.M. *Order of Merit*, G.C.V.O. *Knight Grand Cross of the Royal Victorian Order*, K.C.V.O. *Knight Commander of the Royal Victorian Order*, C.V.O. *Commander of the Royal Victorian Order*, C.B.E. *Commander of the Order of the British Empire*, O.B.E. *Order of the British Empire*, P.R.A. *President of The Royal Academy*, R.A. *Royal Academician* (and *Royal Academy*), A.R.A. *Associate of the Royal Academy*. Bt. after a name means Baronet.
R.A. Diploma: designed by J.B. Cipriani and engraved by F. Bartolozzi, this is signed by the Sovereign and awarded on election as a Royal Academician.

I

Sir Joshua Reynolds, P.R.A. (1723–1792)
King George III
Oil on canvas, 108 × 72 in.

Collection: Painted for the R.A., 1779
Literature: Leslie & Taylor, *Reynolds*, 1865, I,
 pp. 366, 380; II, p. 289; Graves and Cronin,
 Reynolds, 1899, I, pp. 165–7, 356–7; Sir W.
 Armstrong, *Reynolds*, 1900, p. 207; W.T.
 Whitley, *Artists and their Friends*, 1928, I,
 pp. 254–6; *Letters of Reynolds*, ed. F.W. Hilles,
 1929, p. 112; E.K. Waterhouse, *Reynolds*,
 1941, p. 71; S.C. Hutchison, *The History of the
 Royal Academy*, 1968, pp. 66, 84, 158,
 repr. pl. 1
Engraved: Dickinson and Watson, 1781 (E.
 Hamilton, *Engraved Works of Reynolds*, 1884,
 p. 31); R.H. Cromek, J. Heath; F. Bromley,
 1863
Exhibitions: R.A. 1780 (ex. cat.); British
 Institution, 1813 (1); 1843 (4); South
 Kensington, *National Portraits*, 1867 (447);
 R.A. Winter, 1872 (272); 1873 (278); 1906
 (82); 1910 (182); R.A. Diploma, 1953 (238);
 R.A. Winter, 1956 (521); 1963 (7); 1968
 (893); 1982 (31)
Sittings: 17, 21, 26 May 1779

King George III signed the Instrument of
Foundation on Saturday 10 December 1768 and
declared himself the institution's "Patron
Protector and Supporter."

 According to Leslie & Taylor, Reynolds had
made it a condition of accepting the Presidency
of the Academy that he should be granted a
royal sitting. This was the one occasion that the
King and Queen, who found Reynolds
unsympathetic, sat for him. Numerous replicas
of the two portraits were reproduced in the
studio.

 George III (1738–1820) married Charlotte
Sophia (1744–1818) of Mecklenburg-Strelitz in
1761.

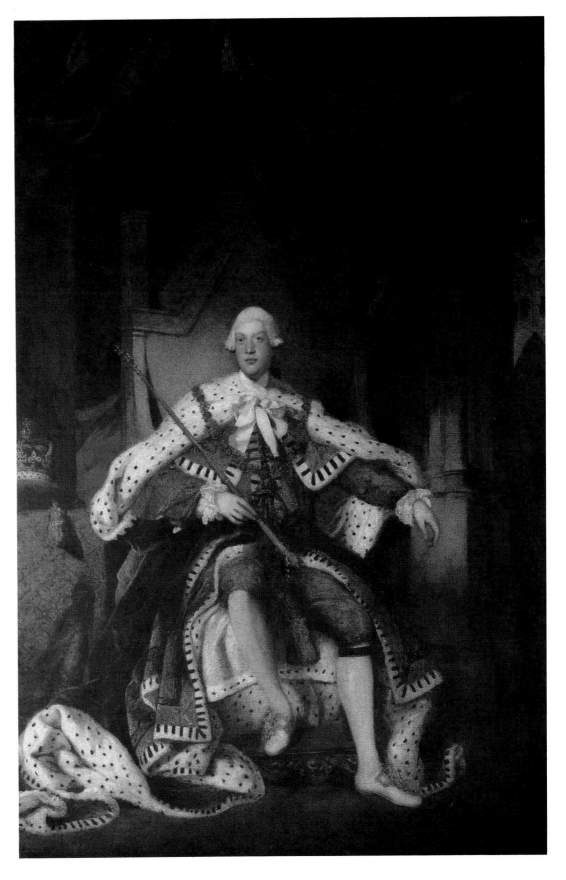

Sir Joshua Reynolds, P.R.A. (1723–1792)
Francis Hayman, R.A.
Oil on canvas, 30 × 25 in.

Collection: Presented by J.E. Taylor, 1837
Literature: Diploma Catalogue, 154, repr.; Leslie
& Taylor, *Reynolds*, 1865, I, pp. 136–7;
Graves and Cronin, *Reynolds*, 1899, II, p. 454;
Sir W. Armstrong, *Reynolds*, 1900, p. 211;
E.K. Waterhouse, *Reynolds*, 1941, p. 41
Engraved: G.H. Every, 1864; Gimber (canceled)
Exhibitions: British Institution, 1854 (157);
Manchester, 1857 (28); South Kensington,
National Portraits, 1867 (340); R.A. Winter,
1884 (204); Exeter, *Devon Painters*, 1932
(244); Sheffield, 1934 (299); Bournemouth,
1957; Nottingham, University Art Gallery,
Diploma Works, etc., 1959 (43); Kenwood,
Iveagh Bequest, *Hayman*, 1960 (48); Arts
Council, 1961 (33); R.A. Winter, 1963 (6);
City Museum and Art Gallery, Plymouth, *Sir
Joshua Reynolds 250th Anniversary Exhibition*,
1973 (33)

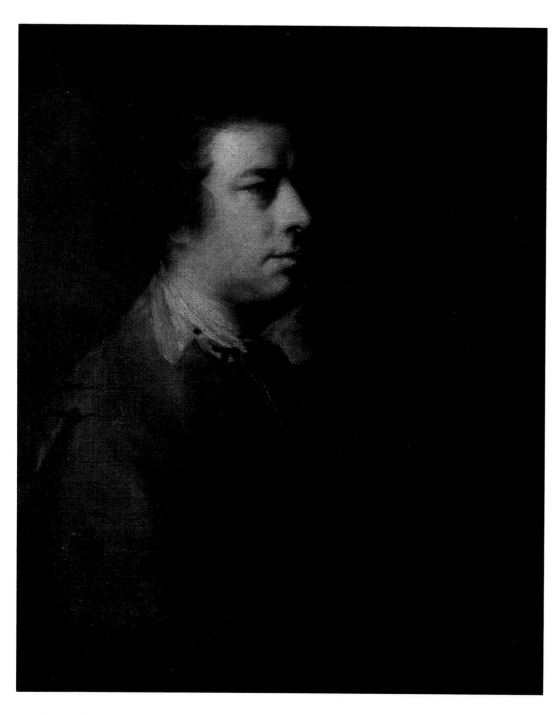

Painted in 1756. Hayman (1708–76), a founder
member and first Librarian of the Academy, is
known primarily for conversation pieces and
small-scale subject pictures. He was apparently
also a painter of histories on a larger scale,
though these have disappeared. He was
described as the "meeting place of two schools,
the English and the Continental" (T.S.R. Boase,
Warburg and Courtauld Journal, X, 1947, p. 91).
According to Leslie & Taylor (Reynolds 1865,
I, pp. 136–7) he had one great claim on
Reynolds's regard – he came from Devonshire.

3

John Keyse Sherwin (1751–1790)

Portrait of the Artist in Cap and Robes of Doctor of Civil Law, Oxford, after Sir Joshua Reynolds, P.R.A.

Line engraving, $10\frac{3}{4} \times 9$ in.

Collection: Provenance and date of acquisition unknown

Engraved: 1784 first state

Sir Joshua Reynolds was the first painter to be honored by a British university. The event marked the elevation of Painting to one of the Arts in England, joining Sculpture, Architecture and Poetry.

The present engraving is based on the *Self-Portrait* (Coll: R.A.) by Reynolds painted for the Academy and presented in 1780 together with a companion portrait of Sir William Chambers (1723–96), Treasurer and Architect of Somerset House.

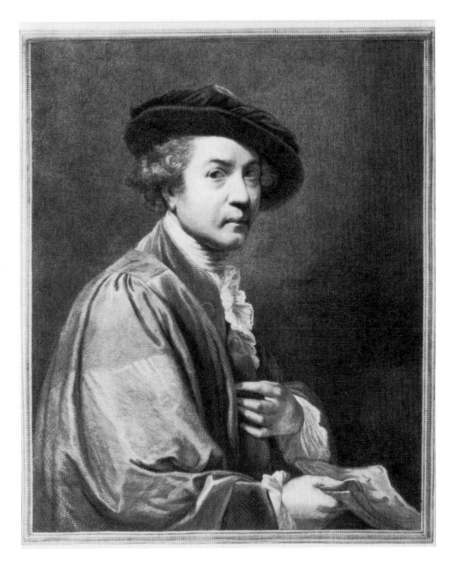

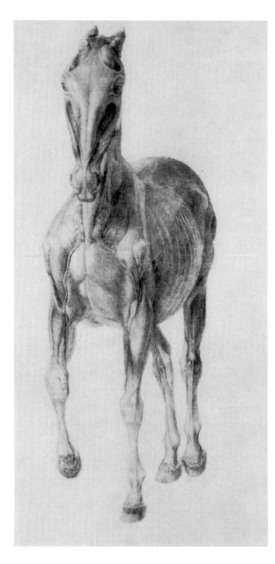

4–6
George Stubbs, A.R.A. (1724–1806)
Drawings for "The Anatomy of the Horse"

4
Ecorché drawing: three-quarter view from the front
Black chalk touched with red, 14 × 7 in.

Collection: Bequeathed by the artist to Mary Spencer 1806; bt. Colnaghi at a sale of her effects, 1817; bt. Sir Edwin Landseer; bequeathed by him to Charles Landseer 1873; who bequeathed them to R.A. 1879
Literature: Ed. J. Mayer, *Memoir of George Stubbs*, 1879, pp. 12–13; Sir W. Gilbey, *Life of George Stubbs*, 1898, pp. 14ff; B. Taylor, *Image* no. 3 (Winter, 1949–50), pp. 35–48; id., *Animal*

Painting in England, 1955, p. 18; S. C. Hutchison, *History of the Royal Academy*, 1968, p. 142; P. Hulton, "A Little-Known Cache of English Drawings," *Apollo*, LXXXIX, 1969, p. 52; C.-A. Parker, *Mr. Stubbs The Horse Painter*, 1971, pp. 18–29
Exhibitions: Eighteen drawings, Liverpool, *Stubbs*, 1951 (69–86); R.A. Winter, 1951 (765); Sheffield, *Stubbs Drawings*, 1952; Whitechapel, *Stubbs*, 1957 (57–74); selected drawings were exhibited subsequently: four at Munich, *Age of Rococo*, 1958 (338a–d); and two at Washington D.C., and New York, *English Watercolors and Drawings*, 1962; R.A. Winter, 1963 (56)

Basil Taylor, in his catalogue entry for the Whitechapel exhibition, records that the Humphry MS (Picton library, Liverpool – three versions included in the material presented to the library by Joseph Mayer) states that Stubbs was encouraged to make this study of horse anatomy by students he had taught at York Hospital, and he had apparently anticipated receiving some support from them, but "the young surgeons having altogether failed to share the labour and expense with him" he was forced to undertake the huge enterprise assisted only by Mary Spencer, his mistress whose son, George Townley Stubbs, was only a few months old. The work was done in a farmhouse which he rented at Horkstow, Lincs., in 1757, and the Humphry MS gives a graphic account of his methods.

"The first subject that he prepared was a horse which was bled to death by the jugular vein: after which the arteries and veins were injected. A Bar of Iron was then suspended from the ceiling of the room by a Teagle to which Iron Hooks of various sizes and lengths were fixed. Under the bar a plank was swung about 18 inches wide for the horse's feet to rest upon and the animal was suspended to the iron bar by the above mentioned hooks which were fastened into the opposite off side of the Horse to that which was intended to be designed by passing the Hooks thro the ribs and fastening them under the back bone; and by this means the horse was fixed in the attitude which these prints represent and continued hanging in this posture six or seven weeks or as long as they were fit for use. His drawings of a skeleton were

previously made and then the operations upon this fixed subject were thus managed.

"He first began by dissecting and designing the muscles of the abdomen proceeding thro five different layers of muscles until he came to the peritoneum and the pleura, through which appeared the lungs and the intestines – afterwards the bowels were taken out and cast away. Then he proceeded to dissect the head by first stripping off the skin and after having cleared and prepared the muscles for the drawing he made careful designs of them and wrote the explanation which usually employed him a whole day. He then took off another layer of muscles which he prepared, designed and described in the same manner as is represented in the work – and so he proceeded until he came to the skeleton. It must be noted that by means of the injection, the muscles, the blood vessels retained their form to the last without undergoing any change. In this manner he advanced his work by stripping off the skin and cleaning and preparing as much of the subject as he concluded would employ a whole day to prepare, design and describe till the whole subject was completed."

He intended that the plates for the book should be engraved by a professional engraver, but he could find no one ready to undertake the work. (Grignon and Bond were among those he approached.) The book was eventually published on 1 March 1766, the price to subscribers being four guineas and to others five guineas. With its twenty-four plates and descriptive figures it was addressed "to those of my profession and those to whose care and skill the horse is usually entrusted whenever medicine or surgery become necessary to him. I thought it might be a desirable addition to what is usually collected for the study of comparative anatomy, and by no means unacceptable to those gentlemen who delight in horses or keep any considerable number of them But what I should principally observe to the reader concerning this my performance, is, that all the figures in it are drawn from Nature, for which purpose I dissected a great number of horses; and that, at the same time, I have consulted most of the treatises of reputation on the subject." In fact the scientific advance represented by this book over all its predecessors, of which the most important had been

Carlo Ruini's treatise of 1598, was enormous both in skill of dissection and correctness of description. The book received considerable acclaim both in the United Kingdom and abroad, the most enthusiastic comments being those of the great Dutch anatomist, Petrus Camper. "The myology-neurology and angiology of men have not been carried to such perfection in two ages, as these horses by you. How is it possible a single man can execute such a plan with so much accuracy and industry I am amazed to meet in the same person so great an anatomist, so accurate a painter and so excellent an engraver." (Gilbey, op. cit., pp. 20, 21)

References: Table nos. refer to the engraved plates in *The Anatomy of the Horse*, 1766.

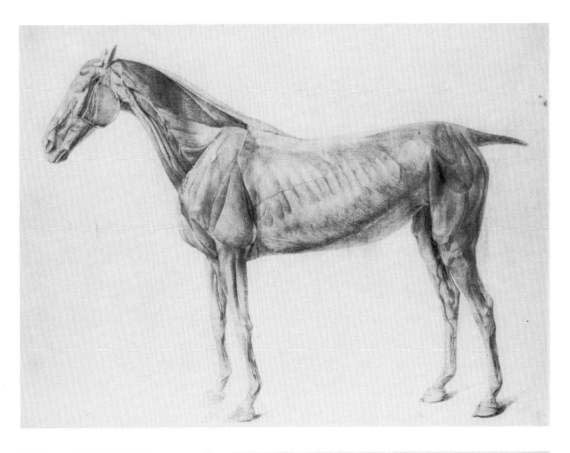

5
Part *écorché* drawing: view from the flank
Black chalk, $14\frac{1}{4} \times 19\frac{1}{2}$ in.

6
Skeleton drawing: view from the flank
Black chalk $14\frac{1}{4} \times 19$ in.

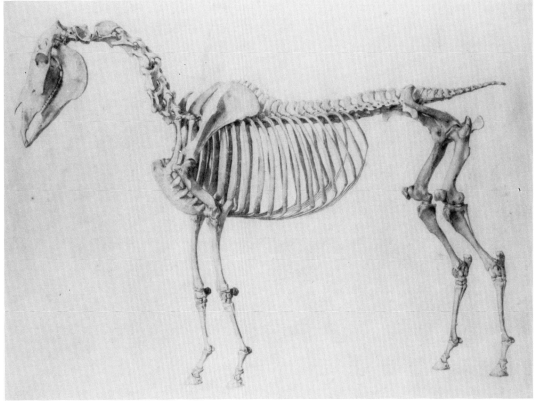

7
Attributed to John Hamilton Mortimer, A.R.A.
 (1740–1779)
The Artist with Joseph Wilton, R.A., and a Student
Oil on canvas, 30 × 25 in.

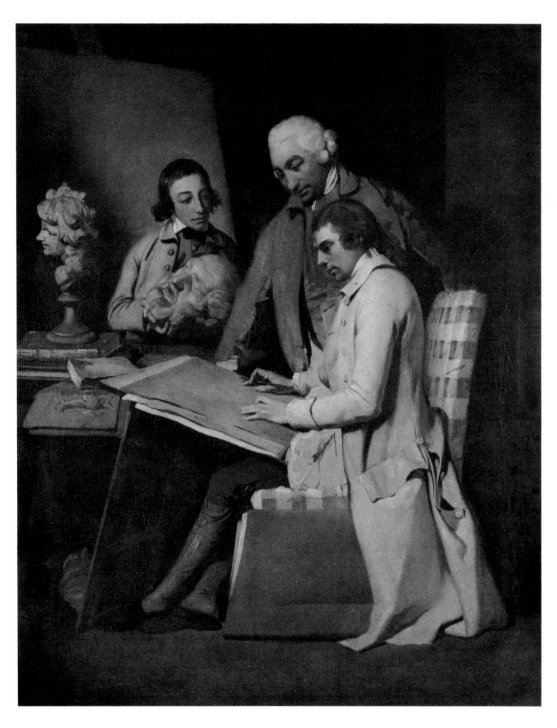

Collection: Presented by T. Humphrey Ward,
 1889
Literature: Diploma Catalogue, 158, repr.;
 W.T. Whitley, *Artists and their Friends*, 1928,
 I, p. 342, repr., pl. 2; C.H. Collins Baker,
 British Painting, 1933, repr., pl. 84
Engraved: The head of Mortimer in this
 composition is engraved in an oval to right
 by Benedictus Antonio Van Assen, titled
 "facsimile from a Drawing in Pen & Ink by
 Himself," (Mortimer) published 1 February
 1810. The lost drawing (to left) was
 evidently copied (? by Mortimer) from his
 self-portrait in the present picture many
 years later, since Van Assen's print reflects
 the style of the 1770s.
Exhibitions: R.A. Winter, 1890 (26); 1934 (302);
 Sheffield, 1934; Nottingham, 1959 (33); Arts
 Council, 1961 (23); Arts Council, *British Self
 Portraits*, 1962 (49); R.A. Winter, 1963 (24);
 British Council, *18th–19th Century British
 Painting for Europe*, 1966 (34); Eastbourne and
 Iveagh Bequest, Kenwood, *Mortimer*, 1968
 (3); R.A. Winter, 1968 (25); British Council,
 British Painting 1600–1800, 1977 (52); R.A.
 Retrospective, 1982 (3)

Mortimer is seated with his teacher, Wilton,
bending over him. The third figure has
traditionally been described as "Thury, the
Academy sweeper at Somerset House." The
inference has therefore been drawn that the
setting for the picture is the Royal Academy
Schools at Somerset House, but as Whitley
observed, this is unlikely. Mortimer never
worked there and Wilton was not Keeper of the
Academy until after Mortimer's death. It is
more reasonable to suppose that it is a room in
the house of the Duke of Richmond, who
allowed his gallery of casts to be used as a
school of art, where Mortimer was a pupil and
Wilton a teacher. The unknown youth is
probably a student; for sartorial reasons alone it
is not easy to see in this figure the Royal
Academy's sweeper. The picture must have
been painted in the early 1760s.

Collection: John Britton, 1822; William Smith, who presented it to the Academy, 1867
Literature: W.T. Whitley, *Artists and their Friends*, 1928, I, p. 342; W.G. Constable, *Wilson*, 1953, p. 233; (pl. 134c)
Engraved: J. Walmesley; J.R. Robins (lithograph)
Exhibitions: R.A. Winter, 1951 (49), with previous references; British Council, 18th and 19th Century Painting from Europe, 1966 (35); R.A. *Retrospective*, 1982 (4)

John Britton, a previous owner of the portrait, regarded it both as by Wilson and of Mortimer and indeed wrote a pamphlet on the subject (published as an appendix to his Autobiography, 1850). Later critics have been more cautious. Constable noted that the dark shadows and modeling on the coat were not characteristic of Wilson. It has also been suggested that Mortimer himself was the painter. Whoever the artist was, he appears to some extent to be emulating Wilson's manner. Doubts about the acceptance of this as representing Mortimer can perhaps be resolved by comparing it with the self-portrait in no. 7.

8
Attributed to Richard Wilson, R.A.
(1713/14–1782)
John Hamilton Mortimer, A.R.A.
Oil on canvas, 29½ × 24½ in.

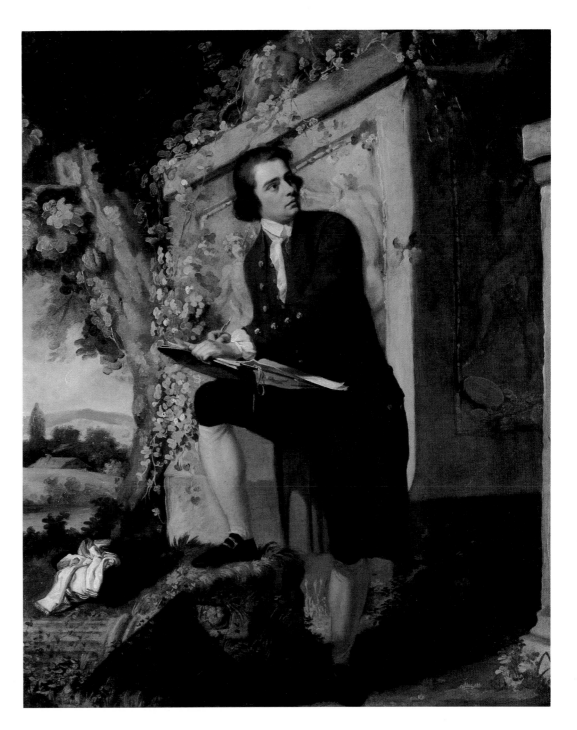

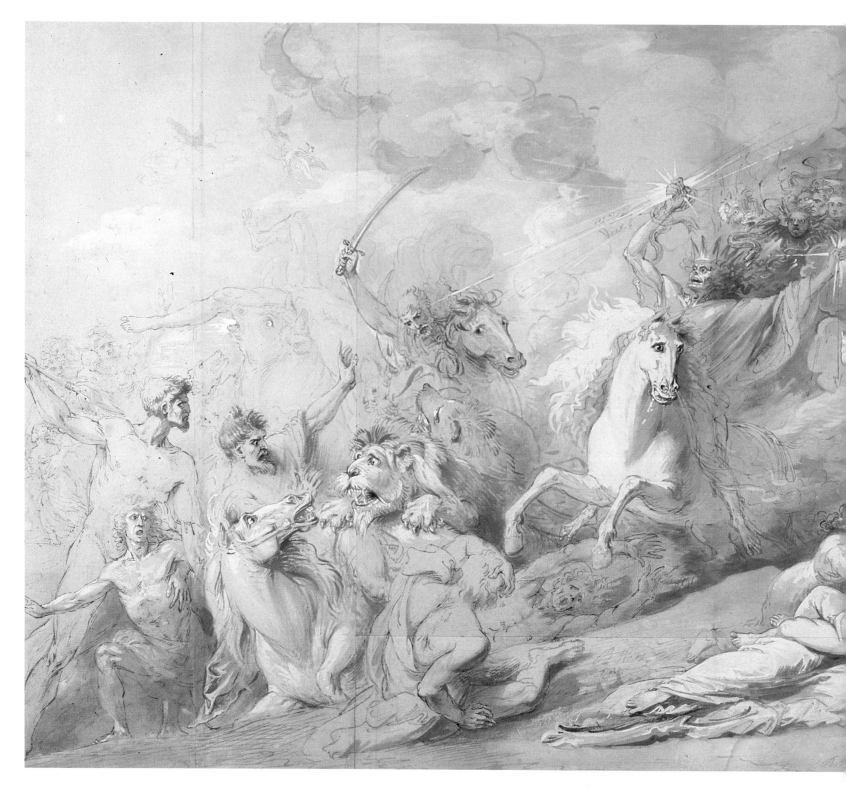

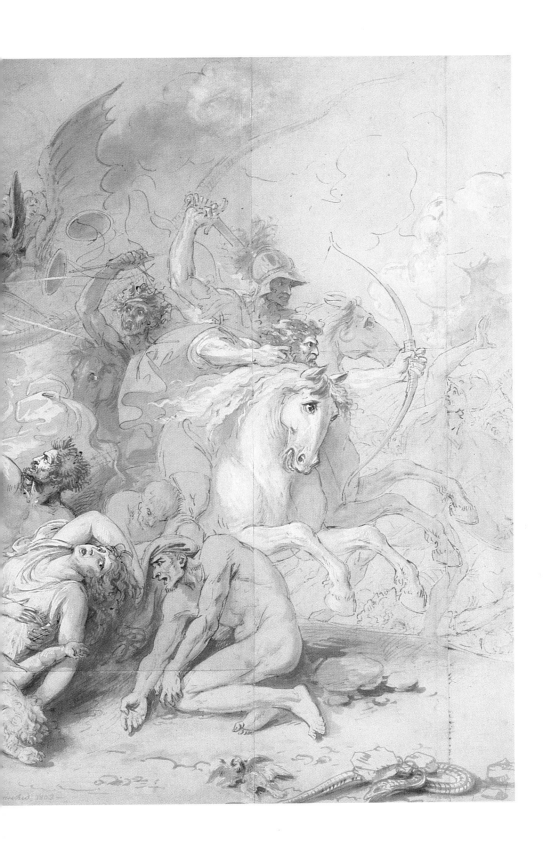

9

Benjamin West, P.R.A. (1738–1820)

Death on a Pale Horse

Pen and brown ink and wash with bodycolor, on brownish sheets of paper irregularly joined, $22\frac{1}{2} \times 44$ in.

Signed and dated: *B West 1783 retouched 1803*

Collection: Provenance and date of acquisition unknown

Literature: Diploma Catalogue, 310; J. Galt, *West*, 1820, p. 233; G. Evans, *West and the Taste of His Times*, 1959, pp. 64, 65, repr. pl. 42; Donald D. Keyes, *Benjamin West's Death on a Pale Horse: A Tradition's End*, 1973, repr. pl. 1, pp. 3–6 ("The Arts," Ohio State University)

Exhibitions: London, Newman Street, 1823 (50); R.A. Winter, 1963 (67); R.A. *Retrospective* 1982 (21); according to records, exhibited at Manchester, 1857, but not included by Graves in *Century of Loan Exhibitions*.

The subject, which is the *Opening of the Five Seals* (Revelations, VI), occupied West's mind sporadically until 1817 when he painted the vast canvas now in the Pennsylvania Academy of the Fine Arts. For the versions q.v. F. Kimball, *Gazette des Beaux Arts*, LXXIV, 1932, pp. 405ff. Evans (op. cit. p. 64) considers that of the four versions of the subject "perhaps the drawing is the most effective. Although it sacrifices obscurity by not having the darkly shaded areas of the paintings, and so loses one important element of Burke's Sublime. Nevertheless the central family group is more emotively conceived Clearly in the drawing the group is unified by a common emotional experience of terror, whereas the paintings have sacrificed much of the intensity originally calculated to play upon the observer's sympathy."

10

Benjamin West, P.R.A. (1738–1820)
The Destroying Angel over the Assyrian Camp
Color wash, heightened with white on pink
 paper, 25 × 18 in.

Collection: Provenance and date of acquisition
 unknown
Literature: Diploma Catalogue, 319 (as *Design*);
 J. Galt, *West*, 1820, p. 233
Exhibitions: R.A. Winter, 1963 (54); Leeds and
 Hull, *American Artists*, 1976; R.A.,
 Retrospective, 1982 (22)

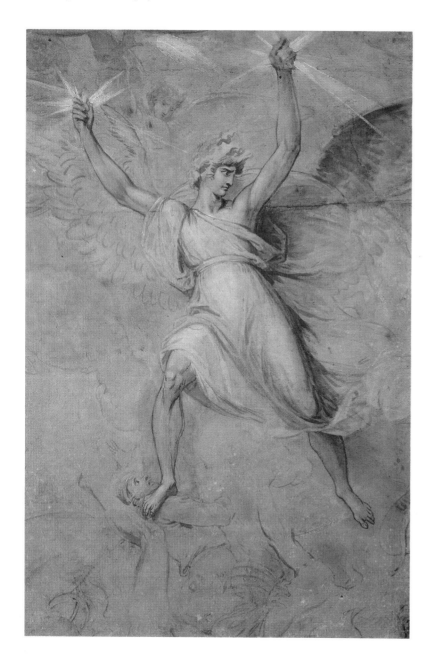

Thomas Gainsborough, R.A. (1727–1788)
Portrait of the Artist
Oil on canvas, $29\frac{1}{2} \times 24$ in. (painted oval)

Collection: Presented to the R.A. by Miss
 Margaret Gainsborough, the artist's
 daughter, 1808
Literature: G.W. Fulcher, *Gainsborough*, 1856,
 p. 205; Sir W. Armstrong, *Gainsborough*,
 1908, pp. 108, repr. 195; W.T. Whitley,
 Gainsborough, 1915, p. 295; E.K. Waterhouse,
 Walpole Society, XXXIII, 1948–50, p. 45; id.
 Gainsborough, 1951, No. 292, pl. 208
Engraved: Bartolozzi, 1798; H. Meyer, 1810
Exhibitions: British Institution, 1814 (42); 1854
 (156); 1859 (114); Manchester, 1857 (310);
 South Kensington, *National Portraits*, 1867
 (519); Leeds, 1868 (1043); R.A. Winter, 1880
 (143); Grosvenor Galleries, 1885 (1); Berlin,
 1908 (61); Rome, 1911 (29); Ipswich,
 Gainsborough Bicentenary, 1927 (73); R.A.
 Winter, 1934 (311); Manchester, *British Art*,
 1934 (63); London, 45 Park Lane, Sassoon,
 Gainsborough, 1936 (19); British Council,
 Lisbon and Madrid, 1949 (20); Arts Council,
 Tate Gallery, *Gainsborough*, 1953 (54);
 Manchester, *European Old Masters*, 1957 (252);
 Arts Council, 1961; Arts Council, *British Self
 Portraits*, 1962 (33); R.A. Winter, 1963 (13);
 1968 (897); The Iveagh Bequest, Kenwood,
 Gainsborough: The Musical Portraits, 1977; Tate
 Gallery, London, *Gainsborough*, 1981 (136
 repr.)

This unfinished portrait was probably painted
in 1787 and may have been intended for the
artist's great friend, C.F. Abel, who died in that
year. Whitley (op. cit., p. 305) records that this
was the only self-portrait that Gainsborough
wished to have engraved.

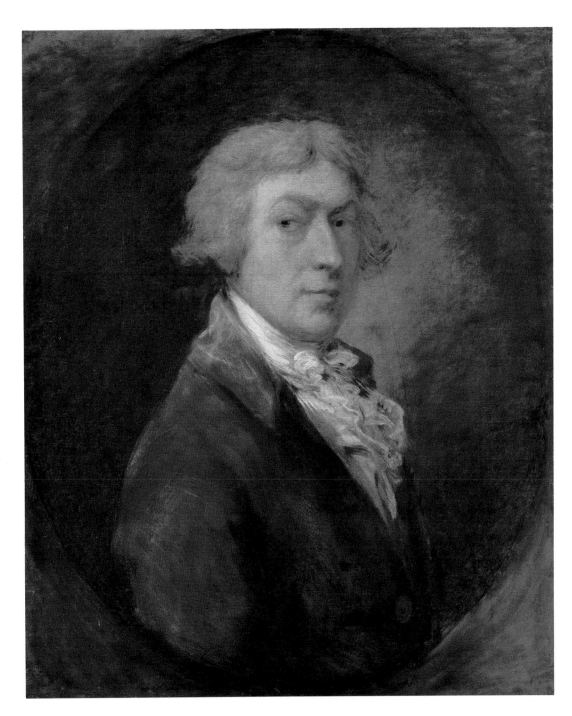

Dominic Serres, R.A. (1722–1793)
Gibraltar Relieved by Sir George Rodney, January 1780
Oil on canvas, $34\frac{1}{2} \times 56\frac{1}{2}$ in.

Collection: Provenance and date of acquisition unknown; probably presented by the artist as the equivalent of a Diploma Work
Literature: D. Cordingly, *Marine Painting in England 1700–1900,* 1974, pp. 83–4
Engraved: R. Pollard, 1782
Exhibitions: R.A. Winter, 1951 (38); Arts Council, 1961 (35); R.A. Winter, 1963 (19); Birmingham, *British Painting 1660–1840,* 1975 (37, repr. b&w, p. 75); British Council, *British Painting 1600–1800,* 1977 (36); R.A. Retrospective 1982 (38)

The British ships are at anchor, with their Spanish prizes following an engagement in which a convoy commanded by Rodney had attacked and defeated a fleet of eleven Spanish ships off Cape St. Vincent. The flagship was the *Sandwich*; Prince William, later William IV, was serving under Rodney's second in command, Admiral Digby, in the *Prince George*.

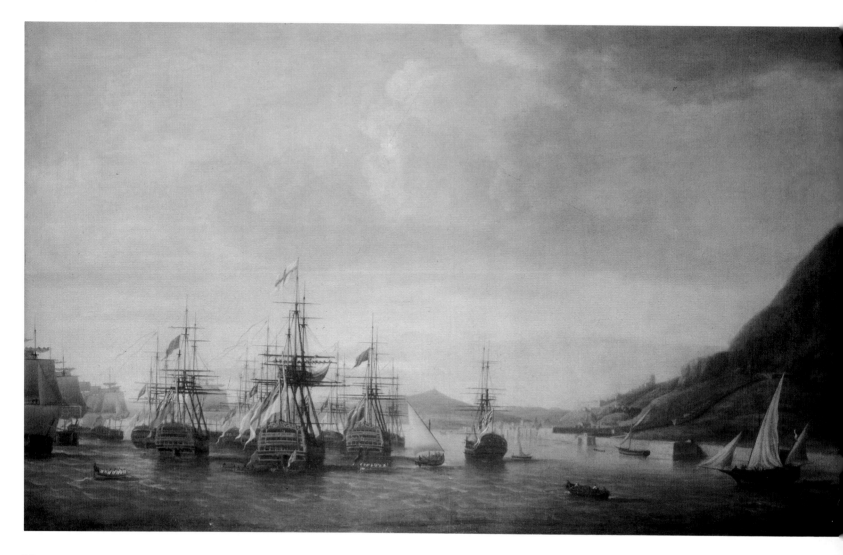

Collection: Diploma Work, 1790

Literature: Diploma Catalogue, 149, repr.; A.
 Federmann, *Fuseli*, 1927, p. 170; D. Irwin, *English
 Neo-Classical Art*, 1966, pl. 119; G. Schiff, Oeuvre-
 Katalog Johann Heinrich Füseli, no. 716

Exhibitions: British Institution, 1844 (150); Manchester,
 1857 (104); Leeds, 1868 (1284); Philadelphia, 1876;
 R.A. Winter, 1951 (56); Bournemouth, 1957;
 Nottingham, *Diploma Works, etc.*, 1959 (24); Arts
 Council, 1961 (13); R.A. Winter, 1963 (17); London,
 Fuseli, 1968; R.A. Winter, 1968 (44); Zurich, *Johann
 Heinrich Füssli*, 1969 (6); London, Tate Gallery, *Henry
 Fuseli*, 1975 (125, repr. b&w and col.)

Fuseli knew Icelandic and had studied with the Swedish
sculptor Sergel in Rome in 1770. His source for this
painting is one of the poems collected by the Elder
Edda, *Hymiskvida* (see Mallets, *Northern Antiquities*, 1770,
II, C.134ff; The Twenty-seventh Fable, *Of the journey
undertaken by Thor to go to fish for the great Serpent*). The
incident depicted is the one when Thor, who has gone
out fishing with Hymir, one of the sea giants of
Scandinavian mythology, catches the Serpent of
Midgard, the monstrous snake which has encircled the
world. Eventually Hymir cuts the line and the serpent
slides back into the depths. The figure in the sky is
probably Odin.

The lines illustrated are:

> *"But Thor assured him that they had better go a good way
> further: accordingly they continued to row on, till at length
> Humir [the Giant] told him if they did not stop, they
> would be in danger from the great Serpent of Midgard.
> Notwithstanding this, Thor persisted in rowing further and
> in spite of the Giant, was a great while before he would lay
> down his oars. Then taking out a fishing line extremely
> strong, he fixed to it the ox's head, unwound it, and cast it
> into the sea. The bait reached the bottom, the Serpent greedily
> devoured the head, and the hook stuck fast in his palate.
> Immediately the pain made him move with such violence that
> Thor was obliged to hold fast with both his hands by the pegs
> which bear against the oars: but the strong effort he was
> obliged to make with his whole body caused his feet to force
> their way through the boat and they went down to the
> bottom of the sea; whilst with his hands, he violently drew up
> the Serpent to the side of the vessel."*

John Henry Fuseli, R.A. (1741–1823)
*Thor Battering the Serpent of Midgard in the Boat of Hymir
 the Giant*
Oil on canvas, $51\frac{1}{2} \times 36$ in.

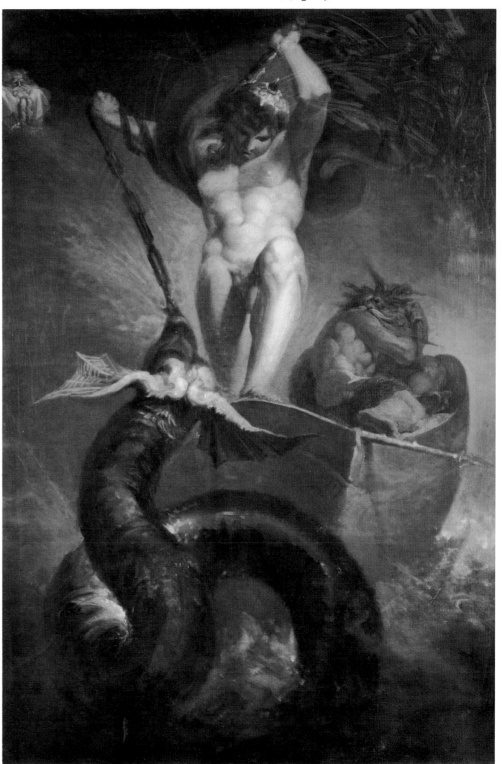

14–16
John Flaxman, R.A. (1755–1826)
Designs for Illustrations to Homer's "Iliad"

14
Thetis Ordering the Nereids to Descend into the Sea
Pen and ink over pencil, $6\frac{3}{4} \times 9\frac{3}{4}$ in.
Inscribed: *18. 176*
Exhibitions: R.A. Winter, 1881 (45.i); 1963 (99)

Drawing for pl. 27; The composition illustrates
the lines, XVII.177:
 "*Ye sister Nereids! to your deeps descend*"

History: When Flaxman was in Rome he received a commission from Mrs. Hare Naylor, the mother of Augustus Hare, to produce a series of designs, at fifteen shillings a sheet, for the *Odyssey* (thirty-four) and the *Iliad* (thirty-nine). He probably carried out the work in 1792, and in the following year both sets were engraved by Piroli. The engravings for the *Odyssey* were lost on the voyage to England, and the work re-engraved by Blake for the English edition, published in 1795, although Piroli's name remained on the title page. The venture was an immediate success. A second English edition appeared in 1805 and others followed in quick succession. In 1880 the Academy bought from Mrs. Hare Naylor thirty-nine of the original drawings for the *Iliad* (of which six were not engraved) and twenty-seven for the *Odyssey* (of which one was not engraved).

Related drawings: Further finished drawings and preliminary studies are owned by the British Museum; others were lent to the 1881 exhibition at the Royal Academy by F.T. Palgrave and the executors of the late C.S. Bale. No attempt is made in the present catalogue to relate them to the designs held by the Academy.

References: These are to Pope's *Homer* and to the 1805 edition of Flaxman's compositions.

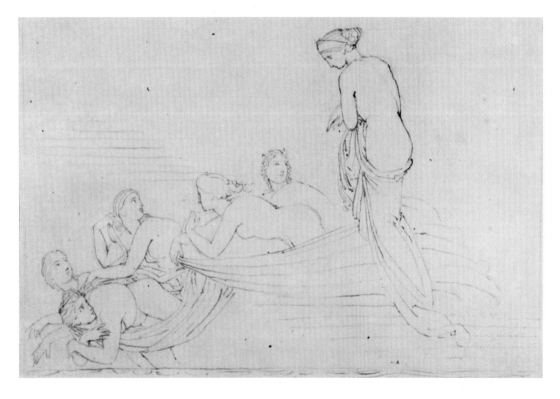

15

Thetis Bringing the Armor to Achilles
Pen and ink over pencil, $6\frac{3}{4} \times 11$ in.

Literature: Essick & La Belle, 1977, p. XXV
Exhibitions: R.A. Winter, 1881 (45.iii); 1963
 (99); British Council, Hamburg, Copenhagen
 and R.A., *John Flaxman* (*Mythology &*
 Industry) 1979 (99)

Drawing for pl. 31; details missing. The
composition illustrates the lines, XIX.450:
 "Th'immortal arms the goddess mother bears
 Swift to her son; her son she finds in tears
 Stretche'd o'er Patrolus' corpse"

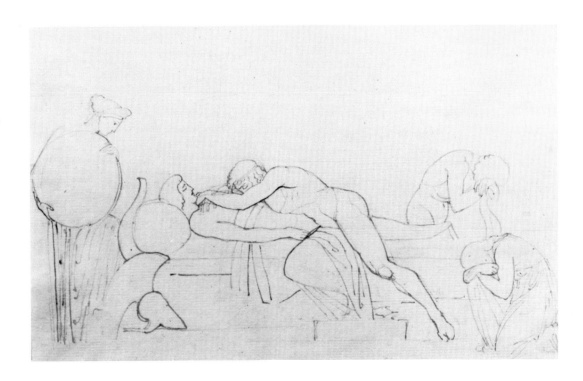

16

Juno Commanding the Sun to Set
Pen and ink over pencil, $6\frac{3}{4} \times 9$ in.

Exhibitions: R.A. Winter, 1881 (45.ii), 1963 (99);
 British Council Munich, *200 years of British*
 Painting, 1977 (67)

Drawing for pl. 28. In the engraving the
positions of Juno's arms have been altered
slightly. The composition illustrates the lines,
XVIII.285:
 "In ocean's waves th'unwilling light of day
 Quench's his red orb, at Juno's high command"

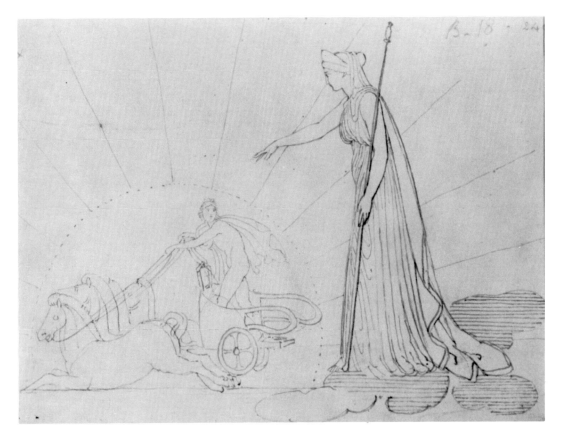

17
Sir Thomas Lawrence, P.R.A. (1769–1830)
A Gypsy Girl
Oil on canvas, $35\frac{1}{4} \times 27\frac{1}{2}$ in.

Collection: Diploma Work, 1794
Literature: Diploma Catalogue, 191, repr.;
 Lord R.S. Gower, *Lawrence*, 1900, p. 175;
 Sir W. Armstrong, *Lawrence*, 1913, p. 176;
 K. Garlick, *Lawrence*, 1954, p. 64; id.
 Walpole Society, XXXIX, 1964, p. 209
Engraved: S.W. Reynolds, 1840
Exhibitions: British Institution, 1855 (114);
 Manchester, 1857 (214); R.A. Winter, 1884
 (201); 1904 (55); 1951 (393); Leicester, *Sir
 George Beaumont and His Circle*, 1953 (67);
 Bournemouth, 1957; Nottingham University
 Art Gallery, *Diploma Works etc.*, 1959 (31);
 Arts Council, 1961; R.A. Winter, 1963 (212);
 R.A. *Retrospective*, 1982 (29)

18
Sir Thomas Lawrence, P.R.A. (1769–1830)
Portrait of the Artist
Oil on canvas, 35 × 25 in.

Collection: Artist's sale, Christie's, 18 June 1831 (150), bt. Earl of Chesterfield (470 gns), from whom acquired by the R.A. 1867

Literature: Lord R.S. Gower, *Lawrence*, 1900, p. 142, repr. p.i; G.S. Layard, *Lawrence's Letter Bag*, 1906, p. 265; Sir W. Armstrong, *Lawrence*, 1913, p. 144, repr. frontispiece; K. Garlick, *Lawrence*, 1954, p. 64; id. *Walpole Society*, XXXIX, 1964, p. 209

Engraved: S. Cousins, 1830; T.A. Dean (frontispiece to Vol. I of Williams, *Lawrence*, 1831); W.C. Edwards (frontispiece to Vol. VI of Cunningham, *Lives of the Painters*, 1833); W. Gillet (title page vignette to *Engraved Works of Lawrence*, 1841); G.T. Doo, 1876

Exhibitions: British Institution, 1833 (14); Manchester, 1857 (302); South Kensington, *National Portraits*, 1868 (353); R.A. Winter, 1870 (235); New Galleries, *Guelph*, 1891 (288); R.A. Winter, 1904 (47); Agnew, *Lawrence*, 1951 (28); Bristol, *Lawrence*, 1951 (20); R.A. Diploma, *Lawrence*, 1961 (10); Arts Council, *British Self-Portraits*, 1962 (61); R.A. Winter, 1963 (31); British Council, Cologne, Rome, Zurich, Warsaw, *XVIII and XIX Century British Art*, 1966 (33); R.A. Retrospective, 1982 (27)

The portrait, dated c.1825 by Garlick, is unfinished.

19
Paul Sandby, R.A. (1725–1809)
Windsor Castle
Gouache, 24 × 36 in.
Signed and dated: *P. Sandby 1794*

Collection: Bequeathed by W.A. Sandby, 1904
Literature: Diploma Catalogue, 309
Exhibitions: R.A. Winter, 1963 (72); Arts
 Council, Reading Museum and Art Gallery;
 Bolton City Art Gallery, *Paul and Thomas
 Sandby*, 1972 (70); R.A. *Retrospective*, 1982 (23)

The north view of the castle from the Eton
bank, the wooden bridge and King's Engine
House at the left. Both this and a similar but
larger gouache of 1801 (P. Oppé, *Sandby
Drawings at Windsor*, 1947, no. 63) derive from a
drawing at Windsor dated 1777 (Oppé, op. cit.,
no. 64).

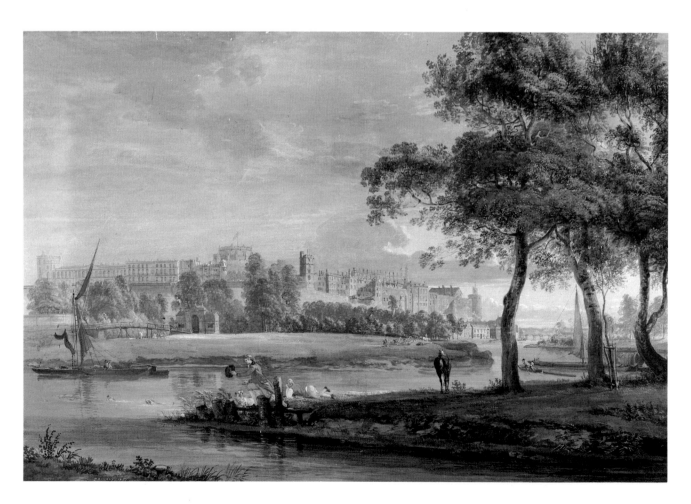

Sir William Beechey, R.A. (1753–1839)
George IV when Prince of Wales
Oil on canvas, 55 × 45½ in.

Collection: Diploma Work, 1798
Literature: Diploma Catalogue, 178, repr.,
 W. Roberts, *Beechey*, 1907, p. 66.
Exhibitions: Manchester, 1857 (222); R.A. 1890
 (30); R.A. Winter, 1951 (403); 1956 (512);
 Nottingham University, *Victorian Exhibition*
 (Arts Council), 1959 (1); Arts Council
 Touring Exh., 1961 (1); R.A. Winter, 1963
 (29); 1968 (189); British Council, Prague,
 Bratislava, and Vienna, *Two Centuries of British
 Council*, 1969 (2, repr.); R.A. *Retrospective*,
 1982 (28)

In this portrait of c. 1797, a variant of a portrait
in the Royal Collection at Windsor, the Prince
is seen wearing the uniform of the 10th Light
Dragoons. A portrait of the Prince of Wales,
which may be the present picture, was
exhibited by Beechey at the Royal Academy,
1797 (91).

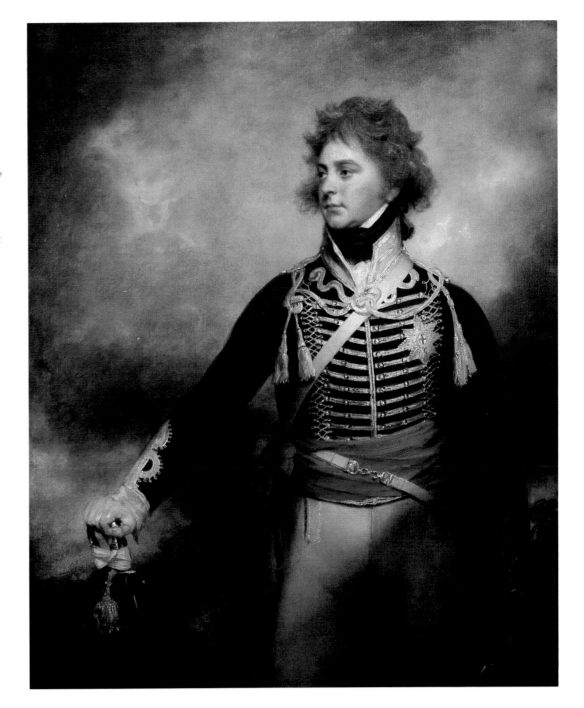

21
Henry Singleton (1766–1839)
The Royal Academicians in General Assembly
Oil on canvas, 78 × 102 in.
Signed and dated: *H. Singleton 1795*

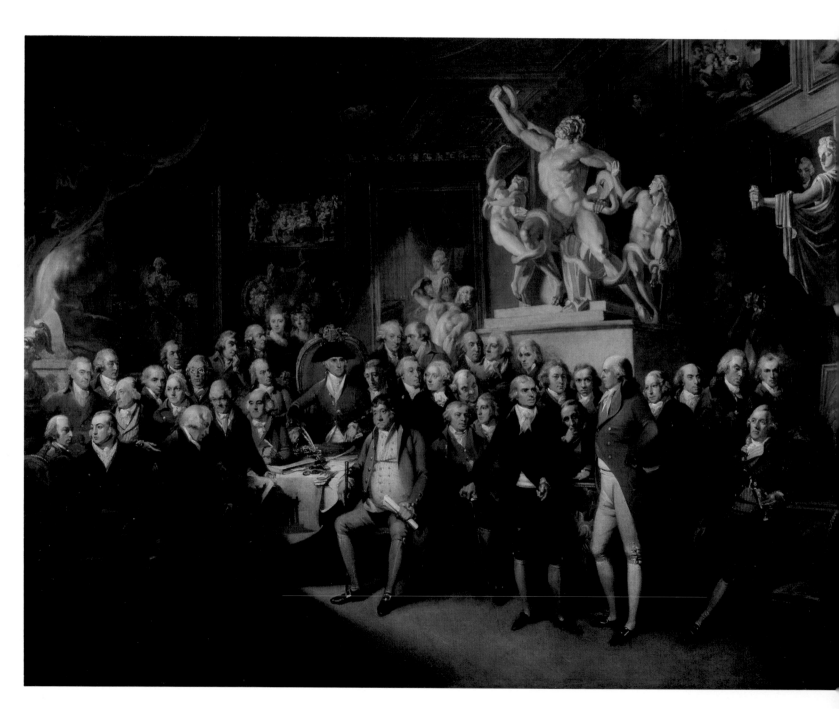

Collection: Presented by Philip Hardwick, R.A., 1861

Literature: S.C. Hutchison, *The History of the Royal Academy*, 1968, p. 65, repr. pl. 21

Engraved: C. Bestland, 1802 (repr. Hodgson and Eaton, *The Royal Academy and Its Members*, 1905, p. 166, with an engraved key to the sitters)

Exhibitions: British Institution, 1822 (291); London, *International Exhibition*, 1862; South Kensington, *National Portraits*, 1867 (520); R.A. Winter, 1870 (225); 1951 (33); 1956 (511); 1963 (264); 1968 (506); Washington, D.C., *Return to Albion*, 1979; R.A. *Retrospective*, 1982 (32)

Surprisingly this picture was never exhibited at the Academy, but four heads of Academicians (including that of Paul Sandby, now owned by the R.A.), which were probably studies for the large picture, were shown in 1797.

The sitters, identified by Bestland's key, include the President, Benjamin West, in the chair with Chambers prominent in the foreground; Lawrence is seated one from the left, and Copley and Farington are standing in front of the cast of the Laocoön. On the wall is West's *Christ Blessing Little Children* between Reynolds's Royal Portraits and, at the right, Copley's *Tribute Money* and Reynolds's self-portrait.

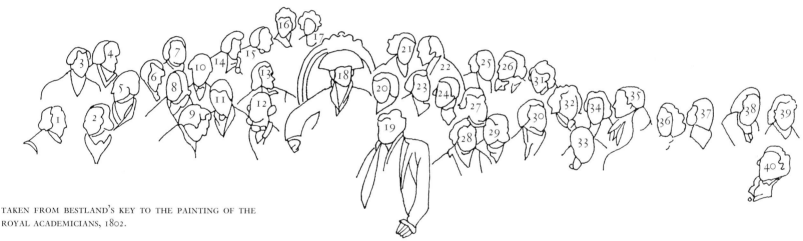

TAKEN FROM BESTLAND'S KEY TO THE PAINTING OF THE ROYAL ACADEMICIANS, 1802.

1. William Hodges, Esq., Late Landscape Painter to the Prince of Wales.
2. Thomas Lawrence, Esq., Principal Painter in Ordinary to his Majesty.
3. James Wyatt, Esq., Architect.
4. William Tyler, Esq., Architect.
5. George Dance, Esq., Professor in Architecture, and Auditor.
6. Sir Wm. Beechey, Portrait Painter to Her Majesty.
7. Charles Catton, Esq., Painter.
8. Francis Wheatly, Esq., Painter.
9. Thomas Sandby, Esq., late Professor in Architecture.
10. Joseph Wilton, Esq., Keeper, Sculptor.
11. Edward Burch, Esq., Librarian and Medallist to his Majesty.
12. John Richards, Esq., Secretary, Painter.
13. Ozias Humphry, Esq., Portrait Painter in Crayons to his Majesty.

14. Thomas Stothard, Esq., Painter.
15. Joseph Nollekens, Esq., Sculptor.
16. Angelica Kauffman, Painter.
17. Mary Lloyd, Painter.
18. Benjamin West, Esq., President and Historical Painter to his Majesty.
19. Sir William Chambers, Architect, late Treasurer.
20. Francesco Bartolozzi, Esq., Engraver to his Majesty.
21. Paul Sandby, Esq., Painter.
22. Johan Zoffany, Esq., Painter.
23. Philip James de Loutherbourg, Esq., Painter.
24. Richard Cosway, Esq., Principal Painter to the Prince of Wales.
25. Edmund Garvey, Esq., Painter.
26. Henry Fuseli, Esq., Professor in Painting.
27. John Francis Rigaud, Esq., Painter.
28. James Barry, Esq., late Professor in Painting.

29. Sir Francis Bourgeois, Landscape Painter to his Majesty and to the King of Poland.
30. John Singleton Copley, Esq., Painter.
31. Richard Westall, Esq., Painter.
32. Robert Smirke, Esq., Painter.
33. James Northcote, Esq., Painter.
34. John Opie, Esq., Painter.
35. Joseph Farington, Esq., Painter.
36. William Hamilton, Esq., Painter.
37. John Russell, Esq., Crayon Painter to his Majesty and the Prince of Wales.
38. Thomas Banks, Esq., Sculptor.
39. John Hoppner, Esq., Portrait Painter to the Prince of Wales.
40. John Bacon, Esq., Sculptor.

22
Joseph Mallord William Turner, R.A.
 (1775–1851)
Durham Cathedral from the Bridge
Watercolor, 12 × 16 in.
Signed: *J.W. Turner*

Collection: Given by the artist to John Hoppner,
 R.A.; Mrs. Thackeray (the daughter of John
 Yenn, R.A.) bequeathed it to the R.A., 1865
Literature: A.J. Finberg, *Turner*, 1939, p. 53n;
 G. Wilkinson, *Turner's Early Sketchbooks*, 1972,
 pp. 94–5
Exhibitions: R.A. Winter, 1887 (69); Leeds,
 1889; R.A. Winter, 1963 (91); R.A.
 Retrospective, 1982 (24)

Turner's gift of this drawing to Hoppner was
noted by Farington (*Diary*, 24 October 1798).

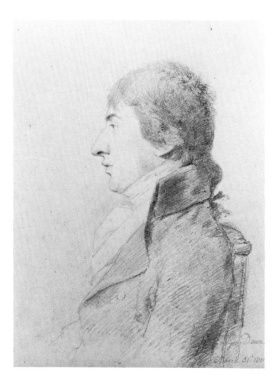

23
George Dance, R.A. (1740–1825)
J.M.W. Turner, R.A.
Black chalk, touched with pink, 10 × 7¾ in.
Signed and dated: *Geo. Dance March 31st 1800*

Collection: (?) bt. by the R.A., 1813
Literature: W. Gaunt, *Connoisseur*, CLVIII, 1963,
 p. 182; repr.
Exhibitions: R.A. 1800 (363); R.A. Winter, 1907
 (179); Tate Gallery, 1921; R.A. Winter, 1951
 (741); 1963 (94); Hounslow Council for the
 Arts, Chiswick House, *18th Century Drawings
 and Watercolours*, 1969 (no catalogue); Geffrye
 Museum, *George Dance*, 1972 (96 repr.); R.A.
 Retrospective, 1982 (14)

George Dance, the architect brother of
Nathaniel, drew as a relaxation a series of
profiles of early Members of the Academy, of
which fifty-three are at Burlington House. Done
in black chalk, often lightly touched in color,
the majority are dated from 1793–1800.
Seventy-two were engraved in aquatint by
William Daniel and were published 1808–14.

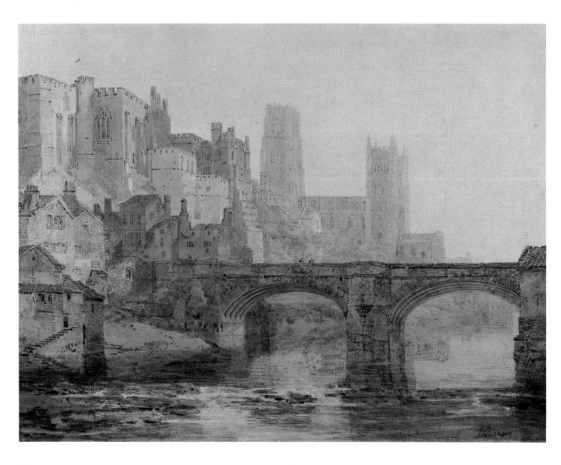

24
Joseph Mallord William Turner, R.A.
 (1775–1851)
Dolbadern Castle
Oil on canvas, 47 × 35½ in.

Collection: Diploma Work, 1802
Literature: Diploma Catalogue, 64, repr.; W.T.
 Whitley, *Art in England, 1800–20*, 1928,
 p. 29; A.J. Finberg, *Turner*, 1939, pp. 67, 77,
 463; G. Reynolds, "British Paintings from
 the Foundation to 1837," *Apollo*, LXXXIX,
 1969, p. 39, repr. fig. 9
Exhibitions: R.A. 1800 (200); Manchester, 1857
 (232); Philadelphia, *International Exhibition*,
 1876; R.A. Winter, 1951 (172);
 Bournemouth, 1957; Brighton, *Influence of
 Wales in Painting*, 1957 (31); Nottingham,
 1959 (47); Arts Council, 1961 (37); R.A.
 Winter, 1963 (40); Arts Council (Wales),
 1964; R.A. Winter, 1968 (885); British
 Council, U.S.S.R., *Turner*, 1975–6

The following lines accompanied its original
exhibition:
 "How awful is the silence of the waste
 Where nature lifts her mountains to the sky
 Majestic solitude beheld the tower
 Where hopeless OWEN long imprison'd, pin'd
 And wrung his hands for liberty in vain."
Turner was in North Wales in 1798, and
sketches of Dolbadern are included in the *North
Wales* and *Hereford* sketchbooks of that year, and
in the Dolbadern sketchbook of the following
year. On his election as an Academician,
Turner, having submitted the *Dolbadern*,
subsequently offered for some reason an
alternative picture (title unrecorded) but the
original deposit was unanimously selected
(Whitley, op. cit. p. 29).

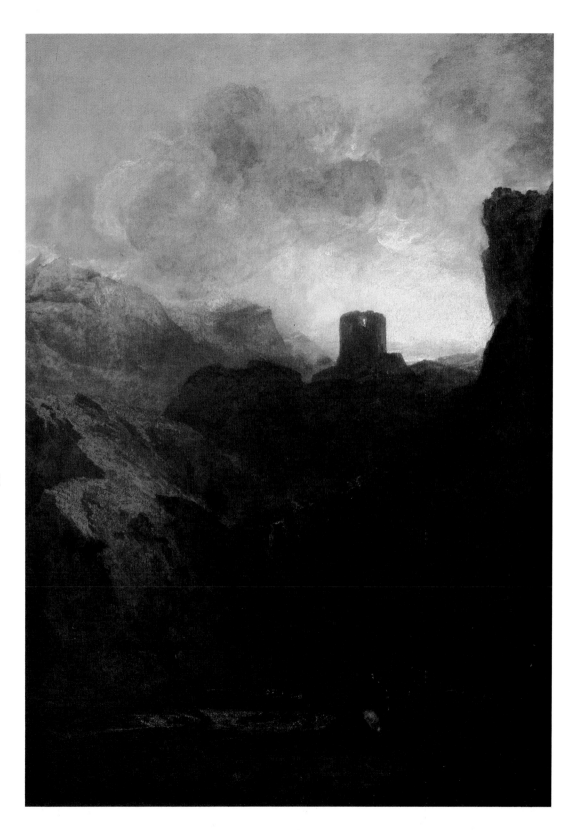

William Owen, R.A. (1769–1825)
Boy and Kitten
Oil on canvas, 30 × 24½ in.
Signed and dated: *W Owen 1807*

Collection: Diploma Work, 1806
Literature: Diploma Catalogue, 161, repr.
Engraved: Henry Meyer, 1810 (as *Puss in Hopes*)
Exhibitions: British Institution, 1945 (147); 1858
 (170); London, *International Exhibition*, 1862
 (97); Philadelphia, *International Exhibition*,
 1876; R.A. Winter, 1896 (92); Arts Council,
 1961 (29); R.A. Winter, 1963 (109); London,
 Camden Arts Centre, *The English at Table*,
 1969 (118)

The son of a bookseller, Owen was admitted as
a student in the Royal Academy Schools in
1791. Following election as an Associate and,
later, a Royal Academician, he was appointed
portrait painter to the Prince of Wales in 1810,
and in 1813, principal portrait painter to the
Prince as Prince Regent. In his latter years, an
affliction of the spine left him unable to work.
He died suddenly of the effect of laudanum
through a mistake of a chemist's assistant.

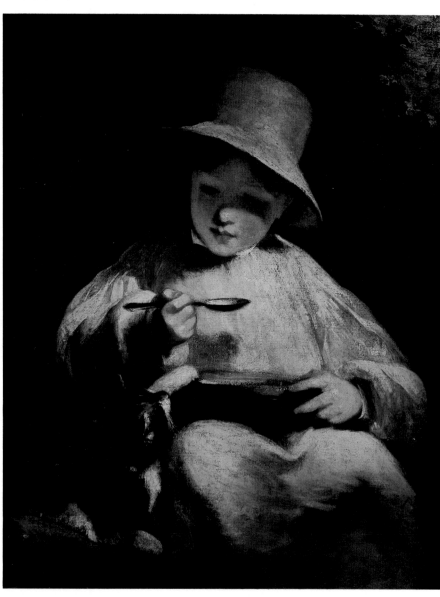

Sir Henry Raeburn, R.A. (1756–1823)
Boy and Rabbit
Oil on canvas, 40 × 31 in.

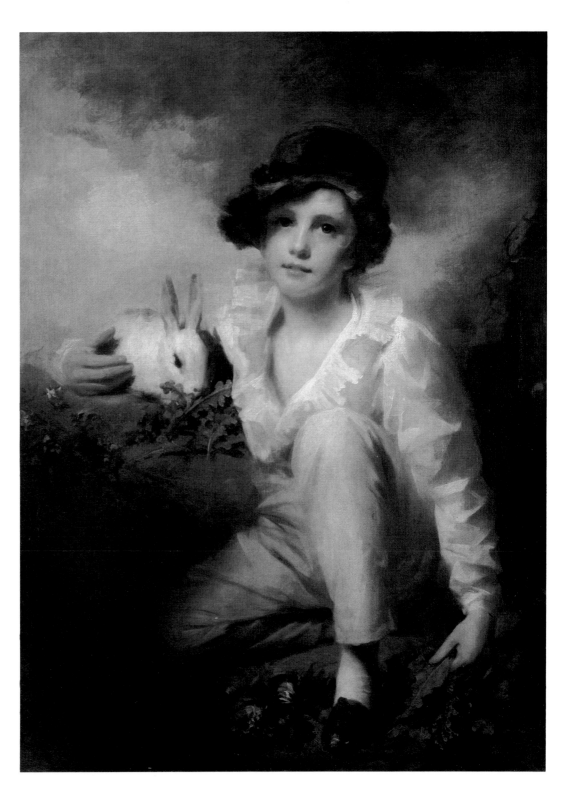

Collection: Diploma Work, 1815
Literature: Diploma Catalogue, 197, repr.; Sir
 W. Armstrong, *Raeburn*, 1901, pp. 47, 115,
 pl. LXIII; Sir J. Greig, *Raeburn*, 1911, p. 39;
 W.T. Whitley, *Art in England 1800–1820*,
 1928, p. 240; S.C. Hutchison, *History of the
 Royal Academy*, 1968, repr., pl. 26
Engraved: J.C. Webb, 1902
Exhibitions: R.A. 1816 (31); Manchester, 1857
 (182); London, *International Exhibition*, 1862
 (162); R.A. Winter, 1873 (226); 1934 (457);
 1939 (87); 1951 (270); Arts Council,
 Edinburgh, *Raeburn Bicentenary*, 1956 (45);
 Bournemouth, 1957; Nottingham, 1959 (41);
 Arts Council, 1961 (31); R.A. Winter, 1963
 (33); 1968 (891); British Council, Tokyo,
 British Portraits, 1975; R.A. *Retrospective*, 1982
 (30)

The diploma picture first sent by Raeburn was
a self-portrait (now Coll: National Gallery of
Scotland no. 930) which was turned down by
the Council on the grounds that it was not
customary to receive as deposits the self-
portraits of members. The present work was
offered as a replacement in August 1816 and was
accepted.

 The sitter is Henry Raeburn Inglis, the deaf
and dumb son of Raeburn's elder stepdaughter
Ann Leslie, wife of Captain James Philip Inglis,
R.N., who died at Calcutta in 1807. When
Raeburn bought St. Bernard's in 1809 and left
Deanhaugh House, the widowed Mrs. Inglis and
her two sons continued to occupy the latter.

John Constable, R.A. (1776–1837)
Landscape Study: Flatford Mill from a Lock on the Stour
Oil on paper laid on canvas, brown ground, $10\frac{1}{4} \times 14$ in.

Collection: Presented by Miss Isabel Constable, 1888
Literature: Diploma Catalogue, 65; A. Shirley, *Constable*, 1944, pl. 9
Exhibitions: Manchester, *Constable*, 1956 (52); Colchester, The Minories, 1958; Nottingham 1959 (8); British Council, U.S.S.R. *British Art*, 1960 (62); R.A. Winter, 1963 (214); Kings Lynn, *Festival Exhibition*, 1964; Folkestone, New Metropole Arts Centre, *10th Anniversary*, 1971 (46); Tate Gallery, London, *Constable*, 1976 (94 repr.); R.A. *Retrospective*, 1982 (11)

The scene is Constable's father's mill. A similar study is in the Victoria and Albert Museum (cf. Graham Reynolds, *Catalogue of the Constable Collection*, 1960, no. 103, pl. 62). The finished painting was in the collection of Senator Clark (sold New York, 12 January 1926, Lot 99), and this may be the same as a picture of Flatford Mill exhibited at the Royal Academy in 1812 (9). In this case Holmes's date of 1811 for the Victoria and Albert sketch is correct (cf. *Constable and His Influence on Landscape Painting*, 1902, p. 242, where the Academy sketch is also mentioned). Reynolds (op. cit.) judges it to be c. 1810–15.

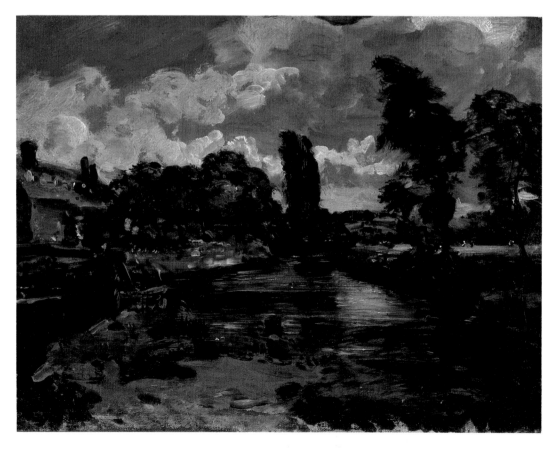

28

John Constable, R.A. (1776–1837)
Landscape Study: Cottage and Rainbow
Oil on paper laid on board, brown ground,
$5\frac{1}{2} \times 8\frac{1}{2}$ in.

Collection: Presented by Miss Isabel Constable,
1888
Literature: Diploma Catalogue, 54; G. Reynolds,
Constable the natural painter, 1965, pl. V, p. 147.
Exhibitions: Sheffield, Graves Art Gallery, 1936;
Manchester, Constable, 1956 (26); R.A.
Winter, 1963 (225); Kings Lynn, *Festival
Exhibition*, 1964; Auckland City Art Gallery,
John Constable, 1973–4 (8 repr. col.); R.A.
Retrospective, 1982 (10)

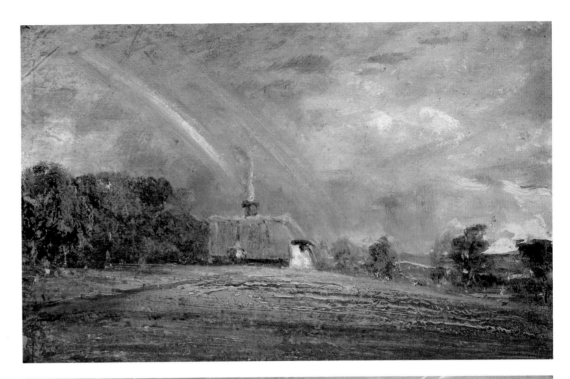

A study of a double rainbow, possibly related,
and evidently done at East Bergholt during the
period 1812–16 (see Victoria and Albert
Museum Constable collection catalogue no.
238–88).
 Reynolds: (op. cit., p. 147) states, "In style
this belongs to the period c. 1810–15, and the
type of thatched cottage suggests that it is a
scene in East Anglia. It is an early example of
the interest which became much more powerful
in his later life. It is to be seen for instance in
his painting *Salisbury Cathedral from the Meadows*."

29

John Constable, R.A. (1776–1837)
Seascape Study: Boat and Stormy Sky
Paper laid on board, brown ground, $6 \times 7\frac{1}{4}$ in.

Collection: Presented by Miss Isabel Constable,
1888
Literature: Diploma Catalogue, 48
Exhibitions: Sheffield, Graves Art Gallery, 1834;
Arts Council, *English Romantic Art*, 1947; (32)
R.A. Winter, 1963 (215); R.A *Retrospective*,
1982 (12)

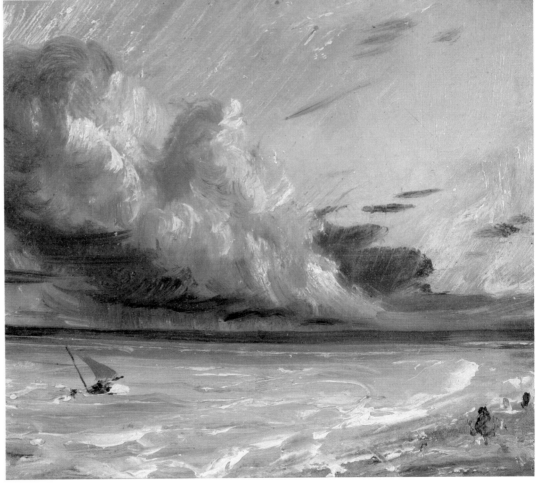

Sketched either at Weymouth or Brighton but
probably at Weymouth when Constable was
there in 1816. Apparently the cloud study
presented here is a very rare phenomenon and
could have lasted only a few minutes.

30

John Constable, R.A. (1776–1837)
Seascape Study: Brighton Beach Looking West
Oil on paper laid on canvas, brown ground,
$7\frac{3}{4} \times 9\frac{1}{2}$ in. (including $\frac{1}{4}$ in. addition at
bottom)

Collection: Presented by Miss Isabel Constable,
1888
Literature: Diploma Catalogue, 53
Exhibitions: Sheffield, Graves Art Gallery, 1934;
Manchester, *Constable*, 1956 (58); R.A.
Winter, 1963 (217)

Dated "probably 1824" in the Manchester
exhibition catalogue, where it was apparently
first identified as a view of Brighton.

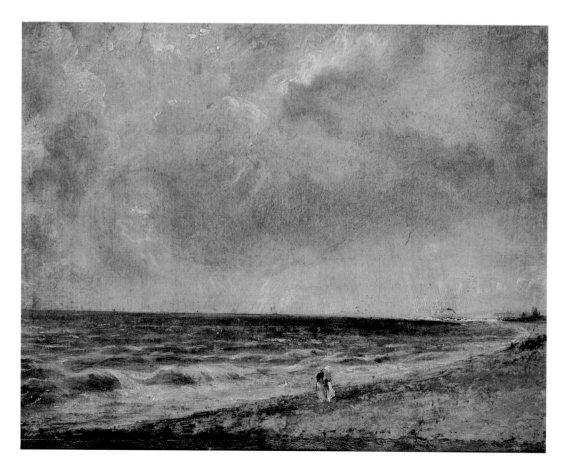

31
John Constable, R.A. 1776–1837
Study for "The Opening of Waterloo Bridge, June 18, 1817, from Whitehall Stairs"
Oil on paper laid on canvas, brown ground, $8\frac{1}{4} \times 12\frac{1}{2}$ in.

Collection: Presented by Miss Isabel Constable, 1888

Literature: Diploma Catalogue, 74; A. Shirley, *Constable*, 1944, pl. 128; D. Sutton, *Connoisseur*, CXXXVI, 1955, pp. 249ff, repr.

Exhibitions: Sheffield, Graves Art Gallery, 1936; Manchester, *Constable*, 1956 (38); Colchester, The Minories, 1958; Nottingham, 1959 (10); R.A. Winter, 1963 (207); British Council, Prague, Bratislava and Vienna, *Two Centuries of British Painting*, 1969 (16); Guildhall Art Gallery, *London and the Greater Painters*, 1971 (25); Folkestone, New Metropole Arts Centre, *10th Anniversary*, 1971 (47); National Maritime Museum, Somerset House, *London and the Thames*, 1977; R.A. *Retrospective*, 1982 (9)

Rennie's Waterloo Bridge was opened by the Prince Regent on 18 June 1817, and the subject was to engage Constable's attention until the finished picture of the State Opening was exhibited at the Royal Academy, 1823 (279). For a discussion of the relationship between the many sketches and alternative compositions, see Sutton, op. cit. The present sketch was translated into the finished painting now in the Cincinnati Museum (repr. Sutton, op. cit., p. 252) and shows this view without the parade of boats which marked the opening festival. It may have been the "Little Waterloo Bridge" mentioned by Constable in a letter to Archdeacon Fisher of 19 January 1824.

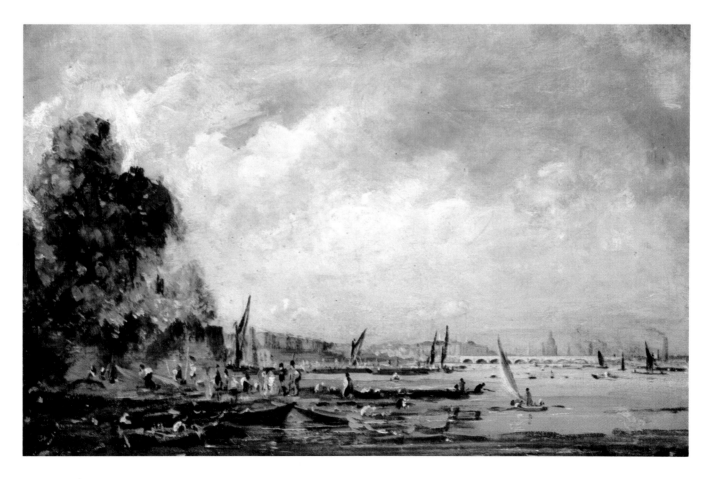

32
John Constable, R.A. (1776–1837)
The Leaping Horse
Oil on canvas, 56 × 73¾ in.

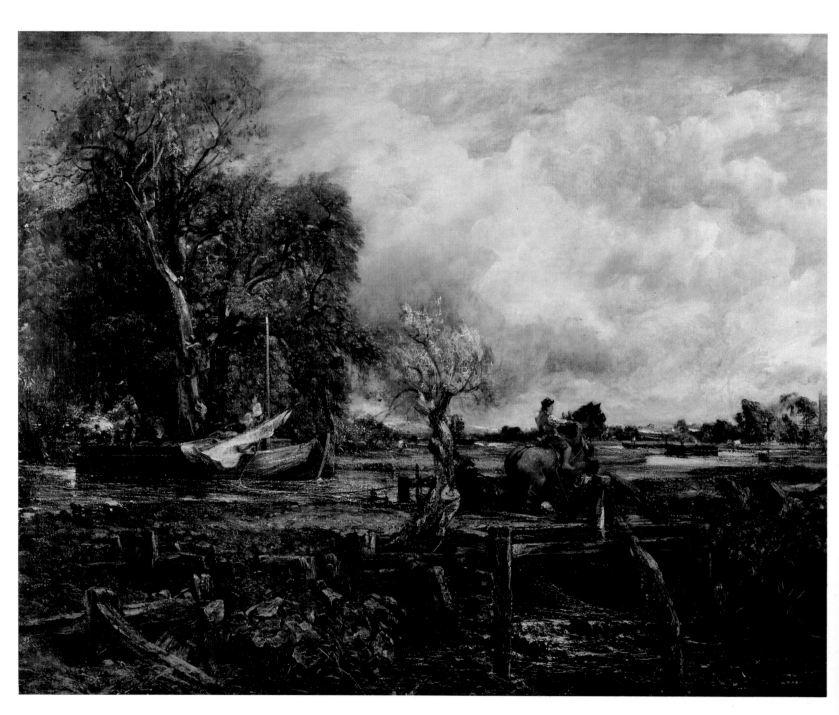

Collection: Constable sale, Foster's May 16, 1838 (35); bt. (?) Archbutt; with Class, 1840–42; Rought; bt. Taunton, 1846 (340 gns); 1849 (150 gns); bt. Creswick, 1849 (£300); Charles Birch Sale, Christie's July 7, 1853 (41) by Gambart; E.F. White, 1863 McConnell; Charles Pemberton 1863; Charles Sartoris, whose wife, later Mrs. Dawkins, presented it to the Academy in 1889.

Literature: C.R. Leslie, *Memoirs of the Life of John Constable*, 1845, pp. 136, 139, 149, 152, 155, 158; C.J. Holmes, *Constable and His Influence on Landscape Painting*, 1901, pp. 9, 19–20, 26, 32; ibid., 1902, pp. 90–91, 121, 247; Lord Windsor, *John Constable R.A.*, 1903, pp. 75–6; W.T. Whitley, *Art in England, 1820–1837*, 1930, p. 87; A. Shirley, *John Constable R.A.*, 1937, pp. lxx–lxxi, 207, pl. IX; Collins Baker, *Burl. Mag.*, LXX, 1937, p. 262; Clark, *Hay Wain*, n.d., p. 16; C. Johnson, *The Growth of Twelve Masterpieces*, 1947, pp. 83–90; S.J. Key, *John Constable, His Life and Work*, 1948, pp. 70, 74–5; Clark, *Landscape into Art*, 1949, pl. 70; Mayne ed. of Leslie, op. cit., 1951, p. 139, pl. 37; R.B. Beckett, *Constable and the Fishers*, 1952 pp. 202, 209–10, 214, 218; J. Mayne, *Sketches*, 1953, p. 5; Reynolds, *Catalogue of the Constable Collection in the V.& A. Museum*, 1959, pp. 172–4 (under no. 286); K. Clark, *Looking at Pictures*, 1960, pp. 112ff

Engraved: J. and G. Nicholls, for the *Art Journal*, 1855, p. 9, as in the collection of Mr. Gambart.

Exhibitions: R.A. 1825 (115); R.A. Winter, 1890 (159); 1896 (124); 1903 (14); Berlin, *Ausstellung Aelterer Englischer Kunst*, 1908 (71); Rome, International Fine Arts Exhibition, British Section, 1911 (16); Brussels, *Peinture Anglaise*, 1929 (26); R.A. Winter, 1934 (192); Manchester, *British Art*, 1934; Brussels, 1935 (1103); Amsterdam, *Twee Eeuwen Engelsche Kunst*, 1936 (25); London, *Constable*, 1937 (30); Chicago and New York, *Hogarth, Constable, Turner*, 1946 (33); British Council, Lisbon and Madrid, *Cien Años di Pintura Britànica*, 1949 (3); R.A. Winter, 1951 (216); Rotterdam, *Engelse Landschapschilders*, 1955 (20); Manchester, *Constable*, 1956 (41); Arts Council, Tate Gallery, *Romantic Movement*, 1959 (70); British Council, U.S.S.R., *British Art*, 1960 (59); R.A. Winter, 1963 (268); Indianapolis, *Romantic Era, 1750–1850*, 1965 (39); British Council, Cologne, Rome, Zurich, Warsaw, *XVIIIth and XIXth Century British Art*, 1966 (9); R.A. Winter, 1968 (99); Arts Council, Mauritshuis, The Hague and Tate Gallery, *Shock of Recognition*, 1971 (9 repr.); The British Council, *British Romantic Painting*, 1972 (57); Tate Gallery, *Constable Bicentenary*, 1976 (238, repr. b&w); The British Council, Munich, *Two Hundred Years of English Painting 1680–1880*, 1979 (353); R.A. *Retrospective*, 1982 (7)

The following is part of Constable's description of the painting written just after it had left his studio for the Royal Academy exhibition of 1825: "It is a lovely subject, of the canal kind, lively – and soothing – calm and exhilarating, fresh – and blowing, but it should have been on my easel a few weeks longer." (Letter to Fisher, 8 April 1825.) It was well received by the critics.

The full-scale study for this picture, the sixth and last of Constable's large canal scenes, is in the Victoria and Albert Museum (cf. Reynolds, op. cit., 1959, for this and preliminary studies). Kenneth Clark devotes a chapter to an analysis of the composition in *Looking at Pictures*. It was exhibited in 1825 with the title of *Landscape*. On its return from the exhibition, 7 September, the artist improved its composition by painting out a willow stump at the right, faintly discernible today, and visible in earlier versions; further work is recorded in his journal for 1 October. The picture was relined and reframed in 1952. The recovery of the canvas, which had been turned over the stretcher at the top and right, resulted in an increase in the dimensions of respectively $2\frac{1}{2}$ and $2\frac{3}{4}$ inches, and revealed more of Dedham Church at the right.

As Leslie explains, it was the custom to train the barge-horses to jump over the barriers erected along the towpath to keep the cattle from straying.

Charles Robert Leslie, R.A. (1794–1859)
John Constable, R.A.
Oil on canvas, $6\frac{1}{2} \times 4\frac{1}{2}$ in.

Collection: Presented by Miss Isabel Constable, 1886

Engraved: Mezzotint by David Lucas for his frontispiece to the first edition of Leslie's *Life of Constable*, 1843

Exhibitions: Tate Gallery, London, *Constable*, 1976 (337); R.A. *Retrospective*, 1982 (13)

34
William Etty, R.A. (1787–1849)
Sleeping Nymph and Satyrs
Oil on canvas, $51 \times 70\frac{1}{2}$ in.

Collection: Diploma Work, 1828
Literature: Diploma Catalogue, 61, repr.;
A. Gilchrist, *Etty*, 1855, pp. 252–3; C. Baker
and M.R. James, *British Painting*, 1933,
pl. 120; R. Fry, *Reflections on British Painting*,
1934, p. 106; D. Farr, *Etty*, 1958, pp. 54, 154,
no. 85, pl. 30; G. Reynolds, "British
Paintings from the Foundation to 1837,"
Apollo, LXXXIX, 1969, p. 36, repr. col., pl. 11

Exhibitions: Manchester, 1857 (240); London,
International Exhibition, 1862 (263); Leeds,
1868 (1246); R.A. Winter, 1872 (30); 1894
(100); 1903 (114); 1934 (697); 1951 (417);
Nottingham, University Art Gallery, *Diploma
Works*, 1959 (21); Arts Council, 1961 (11);
R.A. Winter, 1963 (111), 1968 (218), 1982
(41)

This picture has been wrongly associated with a
painting exhibited at the Royal Academy in
1835 entitled *Woods Nymphs Sleeping: Morning*
(Farr, op. cit., no. 107). To Roger Fry, this
pastiche of a Poussin design, *Nymphs Surprised by
Satyr*, a copy of which is in the National Gallery,
London, and the brilliant study of a nude model
were inimical to each other. However, the
present painting is much indebted to Titian's
Venus del Pardo.

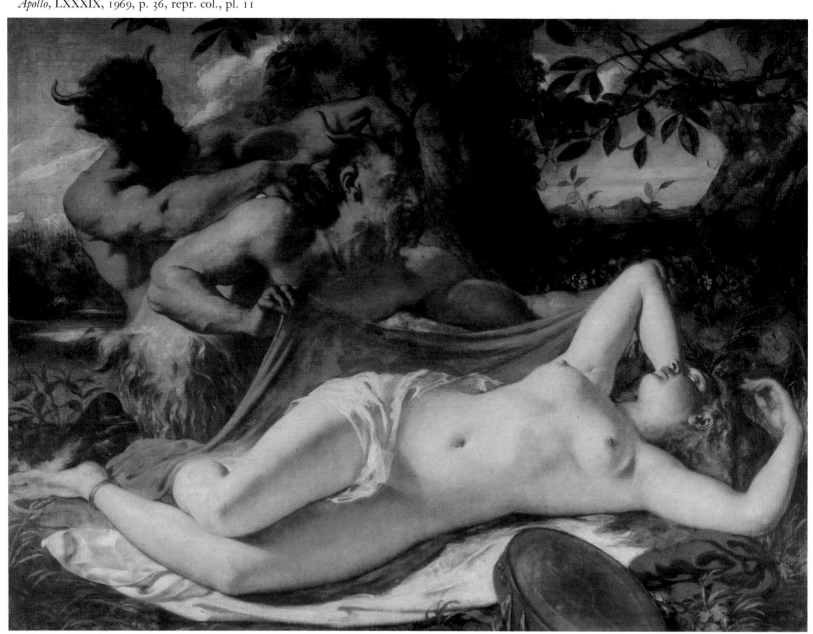

Born in Sunderland of Irish parentage, Stanfield
chose, as a boy, the marine service. He went to
sea and gained some experience perfecting
himself as a seaman. After a fall caused him to
be disqualified from the service, he began a
career as a scenery painter, producing at the
same time marine subjects. He made his first
tour of the continent in 1830.

The present picture, from 1835, was one of
many scenes off the Dutch coast which made
him extremely popular during his lifetime.

35
William Clarkson Stanfield, R.A. (1793–1867)
On the Scheldt near Leiskenshoeck: a Squally Day
Oil on canvas, $37\frac{1}{2} \times 50\frac{1}{2}$ in.

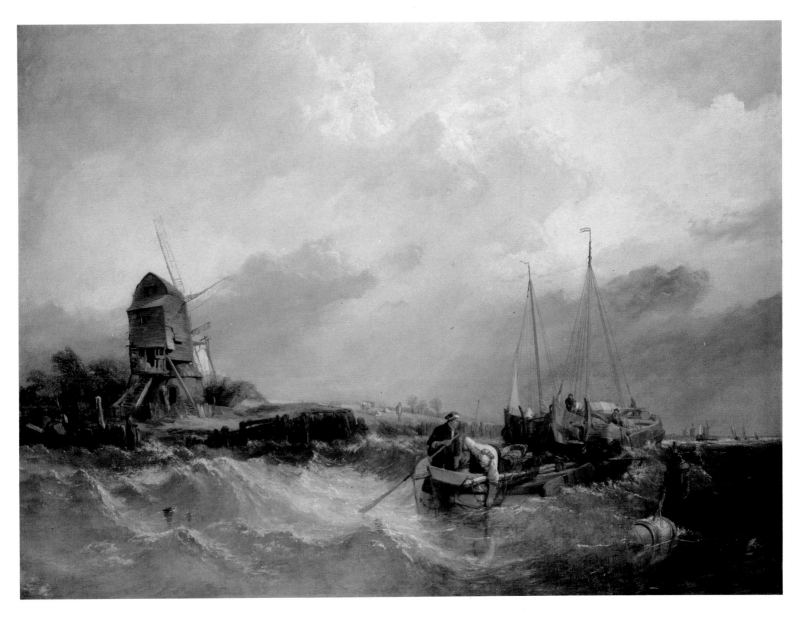

36
Sir Edwin Henry Landseer, R.A. (1802–1873)
John Gibson, R.A.
Oil on canvas, 35 × 27 in.

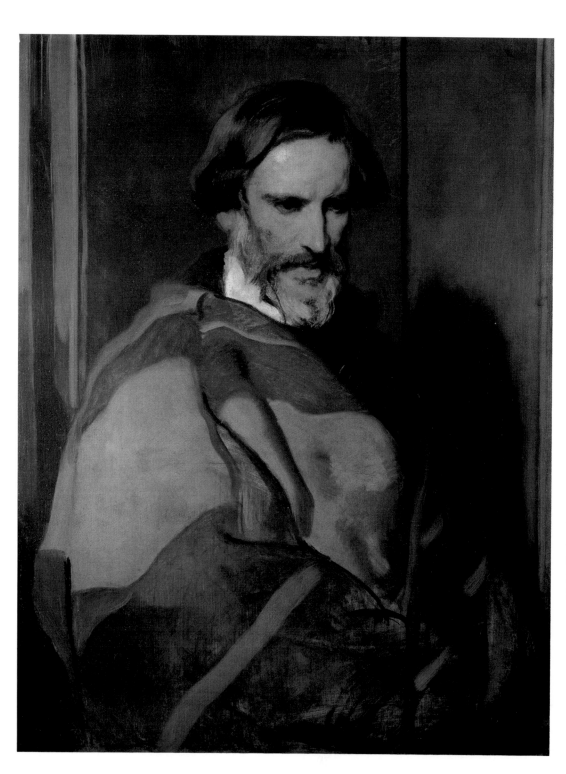

Collection: Presented by the artist's executors, 1874

Literature: Anne Thackeray (Ritchie), "Sir Edwin Landseer," *Cornhill Magazine*, vol. 29 (1874), p. 90; C. Baker and M.R. James, *British Painting*, 1933, pl. 125; Gaunt, 1972, pl. 64; Ormond, 1973, Vol. I, p. 187, vol. 2, pl. 351; Mary Bennett, Merseyside Painters, People and Places, catalogue of oil paintings (Liverpool, 1978), vol. I, p. 136

Exhibitions: R.A. Winter, *Landseer*, 1874 (189); R.A. Winter, 1903 (118); Whitechapel, 1920; R.A. Winter, 1934 (674); Manchester, 1934; Stoke-on-Trent, 1936; R.A. Winter, 1956 (365); Diploma, 1961 (78); Winter, 1963 (266); Ottawa, National Gallery of Canada, *Victorian Artists in England*, 1965 (69); R.A. Winter, 1968 (172); Mappin Art Gallery, Sheffield, *Life and Work of Sir Edwin Landseer*, 1972 (77); Tate Gallery, London, *Landseer*, 1982 (82, repr.).

Gibson (1790–1866) went to Rome in 1817, where he studied sculpture under Canova and Thorwaldsen. He worked there for the rest of his life visiting England in 1844 and 1850. It was probably on the second of these occasions that the portrait was painted. A variant is in the Walker Art Gallery, Liverpool. Gibson's bequest to the Academy, from which the cost of building the Diploma Galleries was largely met, also included the contents of his studio and accounts for the large number of his works present at Burlington House today. The portrait is unfinished.

Collection: Diploma Work, 1853

Literature: Diploma Catalogue, 28, repr.;
 W.P. Frith, *Autobiography*, 1887, I, pp. 247–9;
 N. Wallis (ed.), *A Victorian Canvas: The
 Memoirs of W.P. Frith*, 1957, repr. opp. p. 36;
 R. Ormond, "The Diploma Paintings from
 1840 onwards", *Apollo*, LXXXIX, 1969, p. 57,
 repr. col., pl. III; J. Maas, *Victorian Painters*,
 1969, p. 113, repr.

Exhibitions: R.A. Winter, 1911 (51); 1951 (317);
 Harrogate, *Frith*, 1951 (22); Bournemouth,
 1957; Nottingham, University Art Gallery,
 Victorian Paintings, 1959 (22); R.A. Winter,
 1963 (227); Museum and Art Gallery Service
 for the Midlands Touring Exhibition,
 Victorian Painting, 1965; South London Art
 Gallery, *Mid-Victorian Art*, 1971 (6); British
 Council, Tokyo, *British Portraits*, 1975;
 R.A. *Retrospective*, 1982 (35).

Related drawings are a chalk study belonging to
the Royal Academy and a pen and ink sketch –
part of an album lent to the Harrogate
exhibition (no. 57) by Mr. Gilbert Davis.

J. Maas, op. cit., records that "the model, an
orange seller, had no conversation, and,
consumed with lethargy, fell fast asleep. Frith
had engaged her by becoming a 'large
purchaser' of oranges. She had first insisted,
being Irish and Roman Catholic, on Frith's
obtaining permission from her priest. Although
the permission was never forthcoming, she
finally consented to sit."

Frith himself refers to the picture as *The
Sleepy Model*, and it has also been described as
The Village Model.

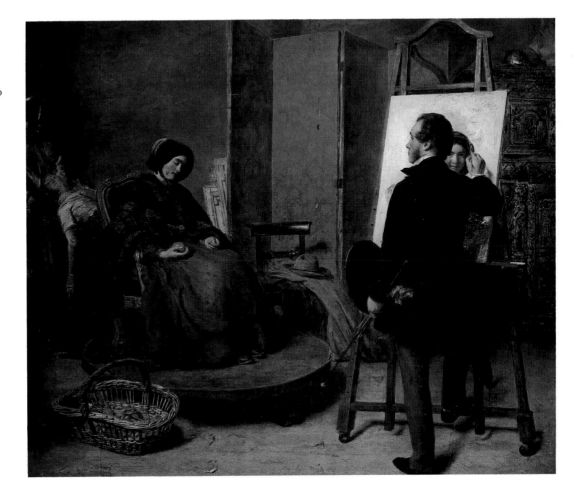

38
Sir John Everett Millais Bt., P.R.A. (1829–1896)
A Souvenir of Velasquez
Oil on canvas, 40 × 32 in.
Signed and dated: *JEM* (monogram) *1868*

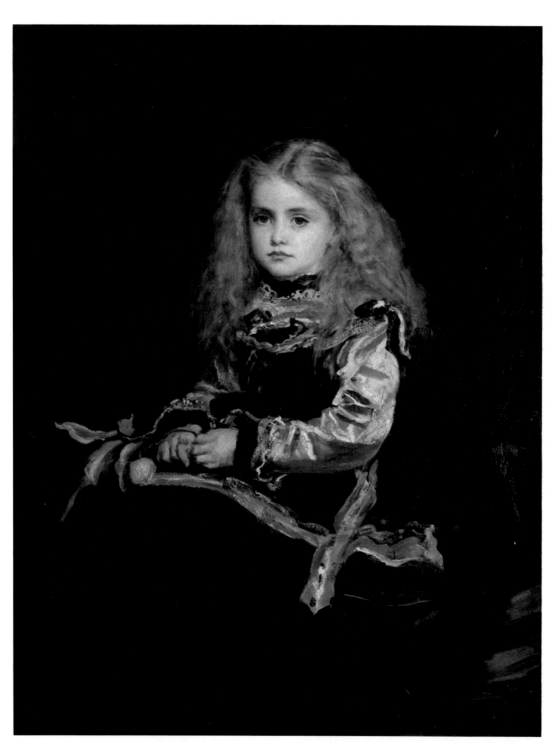

Collection: Diploma Work, 1863
Literature: Diploma Catalogue 24, repr.; M.H.
Spielman, *Millais and His Works*, 1898, p. 123,
no. 123; J.G. Millais, *Life and Letters of Millais*,
1899, II, p. 17; Keith Roberts, *Art into Art*,
1971, p. 46 (238)
Engraved: Lumb Stocks, R.A., 1883
Exhibitions: R.A. 1868 (623), R.A. Winter, *Works
by Millais*, 1898 (123); R.A. Winter, *British
Artists*, 1901 (101); *Burlington Magazine*,
Sotheby's, London, *Art into Art*, 1971 (238)
R.A. *Retrospective*, 1982 (57)

Keith Roberts, op. cit., p. 46, records, "A child
prodigy, Millais became involved in the Pre-
Raphaelite Movement in 1848. By the early
1860s, however, he was completely out of
sympathy with the minute finish and the high
ideals that the group had originally advocated.
With an extravagant wife and a growing family,
he had to take serious note of what the public
liked and would pay for; they especially liked
pictures of attractive children. *A Souvenir of
Velasquez* is among the first of a long line of
broadly painted, single figure subjects, of which
Cherry Ripe (1879) and *Bubbles* (1886) are the
most notorious. It is symptomatic that Millais
should have fastened on the most obviously
appealing side of Velasquez's art – not that it
was meant to remind the spectator of the great
Spanish master in any but a very general way.
Millais was a shrewd man who learned to watch
carefully for changes in taste; in the second half
of the 1860s, Velasquez was becoming a
fashionable master. *A Souvenir of Velasquez* thus
combines a popular type of imagery with a
tribute to a painter particularly admired by
men of forward-looking views."

39
Sir Edward John Poynter Bt., G.C.V.O., P.R.A.
 (1836–1919)
The Fortune Teller
Oil on canvas, $24\frac{1}{2} \times 29\frac{1}{2}$ in.
Signed and dated: *EJP* (monogram) *1877*

Collection: Diploma Work, 1876
Literature: C. Monkhouse, *Art Journal Annual*,
 1897, p. 14, repr. 18
Exhibitions: R.A. 1877 (503); Bournemouth,
 1957; Harrogate, *Festival of Arts and Sciences*,
 1966; R.A. Winter, 1968 (347); Laing Art
 Gallery & Museum, *Albert Joseph Moore and
 His Contemporaries*, 1972 (118)

A strictly academic artist, Poynter was also, at
various times, Slade Professor of Fine Art,
Director of the South Kensington (later Victoria
and Albert) Museum, and Director of the
National Gallery. He, like Alma-Tadema, was
one of the great "marble" painters, whose
pictures inspired the movie epics of
Cecil B. De Mille.

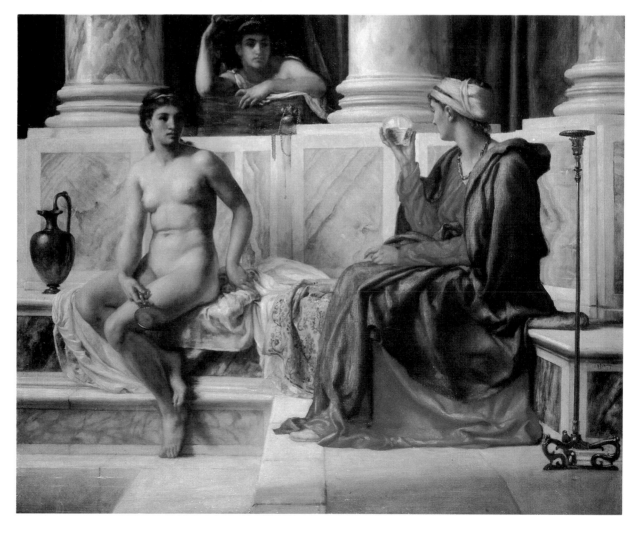

40
Sir Lawrence Alma-Tadema, O.M., R.A.
 (1836–1912)
The Way to the Temple
Oil on canvas, $25\frac{1}{2} \times 17\frac{1}{2}$ in.
Signed: *L Alma-Tadema OP CCXXXIX*

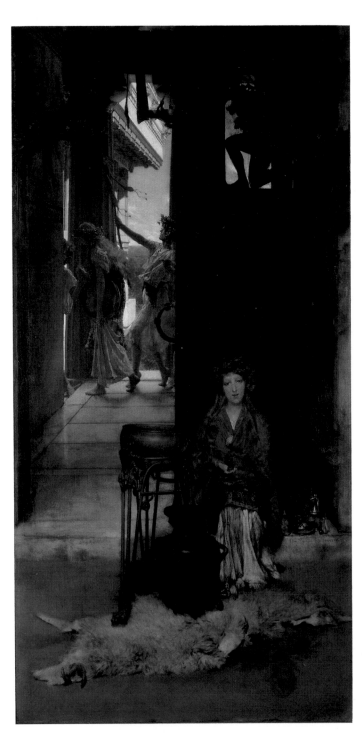

Collection: Diploma Work, 1879
Literature: R.A. *Diploma Catalogue* (20 repr.);
 R.A. *Bicentenary Souvenir*, 1968, p. 11 repr.;
 H. Zimmern, *Art Annual, I*, 1886, p. 27 repr.
Exhibitions: R.A. 1883 (296); R.A. Winter, 1913
 (64); R.A. Bicentenary, 1968 (363); London,
 Royal Society of British Artists, *254th
 Exhibition*, 1971 (26); Sheffield, Mappin Art
 Gallery, *Alma Tadema*, 1976 (13 repr.)

Born in Dronryp, Holland, Alma-Tadema
settled in London in 1870. He was a prolific
painter of Greek and Roman subjects set in
scenes of archeological and architectural
accuracy. He numbered all his works with
Roman numbers. The last, numbered *CCCCVIII*,
was completed two months before his death.

Collection: Diploma Work, 1897
Literature: Diploma Catalogue (102 repr.);
 W.H. Downes, *Sargent*, 1926, pp. 189–90;
 E. Charteris, *John Sargent*, 1927, pp. 163,
 285; C.M. Mount, *John Singer Sargent*, 1955,
 p. 448; R. Ormond, *Apollo*, LXXXIX, 1969,
 pp. 60–1, repr. fig. 6; id., *John Singer Sargent*,
 1970, pp. 54, 63, 70, 251, repr. col., pl. 90;
 J. Maas, *Victorian Painters*, 1969, p. 222 repr.
Exhibitions: R.A. 1900 (729); R.A. Winter, 1926
 (14); Bournemouth, 1957 (840); London,
 Royal Society of Portrait Painters, *Works by
 Past Members*, 1960 (22); Washington, D.C.,
 Corcoran Gallery of Art, *The Private World of
 John Singer Sargent*, 1964 (63 repr.); R.A.
 Winter, 1968 (414); Columbus Gallery of
 Fine Arts, *British Art 1890–1928*, 1971
 (91 repr.); London, Wildenstein, *Venice
 Rediscovered*, 1972 (37 repr. fig. 41); South
 London Art Gallery, *Edwardian Artists*, 1973
 (90); London, Wildenstein & Co., Liverpool,
 Walker Art Gallery, *American Artists in Europe
 1800–1900*, 1976; R.A. *Retrospective*, 1982 (43)

The painting shows Mr. and Mrs. Daniel Curtis
(right), their son, Ralph, and his wife, Lisa,
(left) in the *salone* of the Palazzo Barbaro, their
home in Venice. Ormond (op. cit., p. 251)
points out that Daniel Curtis was an expatriate
American distantly related to Sargent while his
wife was the daughter of an English admiral. A
Boston family, they were leading figures in
Anglo-Venetian Society, and frequently
entertained artists and authors, one of whom
was Henry James who stayed with them in
1886. Sargent, who was an intimate family
friend and a frequent guest, had christened Mrs.
Curtis "the Dogaressa."
 Ormond (op. cit., p. 251) quotes from a letter
of 27 May 1898, which Sargent wrote to Mrs.
Curtis: "The Barbaro is a sort of Fontaine de
Jouvence, for it sends one back twenty years
besides making the present seem remarkably all
right." Mrs. Gardner, for whom Ralph Curtis
acted on occasions as an agent in buying
furniture, was inspired by the Palazzo Barbaro
when she built Fenway Court.

41
John Singer Sargent, R.A. (1856–1916)
An Interior in Venice
Oil on canvas, $25\frac{1}{2} \times 31\frac{3}{4}$ in.
Signed and dated: *John S. Sargent 1899*